DEVELOPER TRAYS

Photographs by
JOHN CYR

Introduction by
LYLE REXER

pH powerHouse Books Brooklyn, NY

FOREWORD

Every photographer working in a darkroom has a tray specifically designated for developer. As a professional silver gelatin printer, I have spent countless hours hovering over my own developer tray in order to produce exhibition prints for photographers, galleries, and museums. After a decade of consistent printing, my tray's appearance became a direct reflection of its treatment: the years of usage, its maintenance, type of developer used, and level of print agitation. Every accumulated tong mark, silver deposit, and chemical stain is present because of the continual repetition of my print processing habits. My developer tray, once sterile and generic, has become one that is uniquely mine.

I knew that the transformation of my developer tray would not be a singular case. All photographers' trays must have their own distinctive attributes. Beyond their unique colors, shapes, and sizes, each developer tray would have a history unlike any other. Once photographed and brought before an audience, the narratives within these developer trays manifest themselves not only visually, but also conceptually in their ability to conjure the archives of each photographer in the mind of the viewer.

This discovery served as a catalyst and I immediately began a three-year quest throughout the United States towards what ultimately became this collection of 82 developer trays. My travels brought me to the homes and studios of photographers such as Sally Mann, Abelardo Morell, and Emmet Gowin. I entered the darkrooms of working practitioners Bruce Davidson, Vera Lutter, and Adam Fuss. Photographers often looked deep into their developer tray and shared with me its history, unapparent beneath the stains and scratches of its weathered surface. For instance, Neil Selkirk's developer tray was acquired from Richard Avedon's studio for the posthumous printing of Diane Arbus's work. While some photographers were entirely unsentimental about their developer tray's existence beyond its functionality, others had a strong attachment because of its role in the scope of their professional development. Andrea Modica's developer tray, still used today, is very dear to her because it was one of her first photo-related purchases from the early stages of her career and has been used to process nearly all of her eight-by-ten inch negatives.

I was granted access to photography artifacts within the collections of the George Eastman House, the Smithsonian Museum of American History, and the O. Winston Link Museum as well as the photo studios of the Metropolitan Museum of Art and the American Museum of Natural History. With thorough research, as well as the help of interested photographers, historians, curators, and gallerists, I was introduced to previous assistants and surviving family members of notable photographers such as Minor White, Arnold Newman, and Ansel Adams. When I visited Ansel Adams' home, I was pleasantly surprised to find his darkroom set up as it had been when he was alive. Complete with a full sink, a few enlargers, and numerous trays of all shapes and sizes, it was easy for me to imagine Adams producing his master prints in the exact location I was standing. While Ansel Adams' family has decided to keep his historic darkroom open and working, it is not a fate that is shared with other notable darkrooms.

Darkrooms are disappearing, and along with them, the strong presence of analog photography and all of its equipment. Many photographers, estates, and archives that I have contacted no longer own any darkroom equipment and were unable to be a part of this collection. John Loengard used the *LIFE* magazine photo lab to make prints until it closed in 2000; he himself has not made any prints in a darkroom since then. Having given up chemical photography and switched to digital, Richard Benson has not used a developer tray for 15 years. The

Richard Avedon Foundation was unable to locate any developer trays that were used in Avedon's studio. Each year that passes, more darkrooms will close to make way for larger and more efficient digital studios. It is likely that the darkroom equipment of many more photographers will continue to be discarded or misplaced.

At this time, there is no object from a photographer's digital process that has the functional longevity of a well-used developer tray. Digital cameras, printers, scanners, and computers continually need to be upgraded and often become obsolete after just a few years. A developer tray does not face this predicament and is never replaced for newer model. Some trays, such as those of Sid Kaplan and Jerry Uelsmann, have been used consistently for as long as 50 years. Along with longevity comes the growing number of prints that have been, and continue to be produced, in these developer trays. Even when the darkrooms housing the trays I have photographed close, the intimate objects will live on, just as a photographer's work is alive in our minds. After viewing the photograph of his developer tray, Richard Misrach wrote, "...that single image holds a tremendous personal history, the simple photographic document containing so much latent information waiting to be released—like a hand grenade—as all photos do." An essential aspect of the individual darkroom experiences of these photographers has been recorded for posterity, ready to captivate our imaginations with each viewing of these thoroughly transformed and unique utilitarian objects.

TOO EARLY TO MOURN, TOO LATE TO CRY

Almost 150 years ago, critics lamented the demise of the daguerreotype even as the infrastructure that supported its production was vanishing. Along Broadway, in Manhattan, photo studios were converting almost overnight to the production of wet plate paper photographs, tintypes, and ambrotypes. Of course these too, in their time, would yield to the film-based output of black and white silver prints in a Darwinian technological struggle whose leveling impact resembles nothing so much as the triumph of Microsoft in the 1990s: unique species vanished. Did expressive possibilities go with them?

That's one of the obvious questions provoked by John Cyr's elegy for the darkroom. For these stained and battered developing trays, requisitioned from the closets, attics, and, in a few cases, working labs of many paragons of chemical photography, testify that even the imperial language, spoken everywhere, can be replaced by another tongue, and it doesn't take long once the regime has been deposed. So the alchemy of toners and fixers, of thermometers and timers and rubber gloves and red lights (as Martin Parr reminds us, eerily reminiscent of brothels), that conjured so many essential images, has been dispersed into a colorless, odorless, *groundless*, infinitely malleable, infinitely adaptable medium. I emphasize this last word. *Alchemy* suggests the transmutation of physical substances though some occult agency, but *medium* suggests a disembodied process, a communication conducted via immaterial ether: our digital universe. I will speak about ghosts later.

Connoisseurs mourned the daguerreotype because they knew, on a basic level, that progress was a fraud. Their own eyes told them that. The loss of the unique properties of the mirror with a memory, as the daguerreotype was called, could not be justified according to any standard except the economic one of faster-cheaper-easier-more distributable, and for artists, that wasn't progress at all.

Can we say the same of chemical photography, especially black and white photography based on silver chemistry? Do we (I say "we," but I am not a photographer, so probably shouldn't presume) really mourn its relegation to the margins of practice? Do we miss the toxicity, the bunker solitude, the industrial invasion of domestic space by a wet closet that's too big? Do we miss the sheer archival bulk of contact sheets and test prints? I can imagine a certain attraction, via photos, to Francis Bacon's astoundingly squalid painting studio, but who among the younger generation of photographers, crammed into shared apartments in Bushwick, could regard with anything but horror (or at best archaeological curiosity), say, Garry Winogrand's apartment, with its thousands of film cans, never processed, a kind of cosmic photographic hoarding? It's not just darkrooms that have vanished but whole habits of being, and just as surely a different sense of space and time involved in the making of pictures.

These trays, then, are containers of space and time, and their scrapes and stains suggest inscriptions from an ancient epoch that fewer and fewer people will be able to decipher (just as fewer and fewer artists, curators, and gallerists will indulge a nostalgia for the analog print). Cyr has deliberately damped down the sentimentality with a rigorous, Becher-like format: the basin of each tray clinically displayed, all different, of course, but all basically the same. Unlike the Bechers' gas works or water towers, the trays lack formal complexity, but just as insistently they remind us that the world has changed and that our aesthetic horizons are shaped by economic forces. And more: the trays recapitulate the entire discourse around photography since its inception, the attempt to sanctify it as a medium of artistic expression first and foremost. Like bodies on an autopsy table, these trays are empty of life and

spirit, drained of the materials that would bring images (and memories) into being. Through the trays we can see photography for what it really is, an industrial process with many uses and audiences, few of which are or ever were concerned with visual pleasure, much less the amplification of the human soul. Just like Baudelaire said.

The art is there only by implication and a list of names of the trays' owners. Which brings us to the people who used them. Here Cyr's project—so contemporary in its clinical monomania—shifts from inventory to poetry. Even without their labels, the trays function as synecdoches, a linguistic term describing a figure of speech that substitutes a part for the whole. In the West, the strategy is as old as the Greek epics, in which armies are described as a forest of spears, and as current as today's political speeches, where soldiers are "boots on the ground." Cyr's trays, many of which sport pinched corners to facilitate pouring, are portraits of the photographers themselves, full frontal, as if they had been cataloged by Chuck Close or a forensic photographer. Mug shots. And like Elliott Erwitt's famous pictures of dogs and their owners, we are solicited to see in the physical contours of the trays the lineaments of the artists and even hints of their practice.

So Andreas Feininger's gleaming tray suggests an exercise in modernist purification, formally precise and apparently untouched by the years. Cyr's photograph appears as an homage to the Bauhaus and its "joy before the object" (to quote the German photographer Albert Renger-Patzsch), which so marked Feininger's famous style. Sally Mann's tray is damaged, discolored, and scratched, the perfect vehicle for the "embodied," decay-obsessed wet plate photography she has embraced. Does Gary Schneider's tray resemble an x-ray? Maybe if you squint a bit. Ellen Carey's looks like a porcelain vessel you might have found in a 19th-century hospital. Can it be coincidental given her frequent references to William Henry Fox Talbot? What do we make of the fact that Adam Fuss's and Bruce Davidson's trays are both unblemished? Vera Lutter's tray is wide but not long, and it's easy to imagine her (or more likely an able-bodied assistant) pulling those giant pinhole prints through the developer and watching the image come into view as the paper unrolls, like a magic scroll painting in a Chinese legend. The trace of an image seems to mark the surface of Mark Cohen's tray, raising the tantalizing possibility that if Cyr only had the right kind of camera, he might have been able to reveal the entire visual history of each photographer's career, deposited in a dense but nearly invisible palimpsest on the surface of the plastic (or in some cases metal). Isn't that the camera every photographer really wants, the camera that can capture what can't be seen, what is only imagined or has been lost for good, even to memory? A camera to prove that there are no ghosts because nothing ever truly vanishes.

Cyr's project belongs on a very short shelf of those books that reveal a great deal about photography without seeming to show us very much, sometimes next to nothing. I would include Mel Bochner's *Misunderstandings (A Theory of Photography)*, a series of truths and falsehoods about the medium gathered on note cards; Will Steacy's *Photographs Not Taken*, a collection of confessions and regrets; Suzanne Doppelt's *Quelque chose cloche*, an indescribable book of fractured philosophizing; and of course, Robert Smithson's *A Tour of the Monuments of Passaic, New Jersey* a peelable onion of expectation and disappointment in regard to the most transparent function of photography.

In truth the shelf is much longer because we are so aware of photography's assumptions, limitations, and implications that all we need is the hint of an image to think about everything in relation to it. Cyr's trays may look like melancholic mementos, but they aren't. They are reminders that photographs are not really objects at all. They are pictures in our heads: that's where they are meant to live and where they will outlive every technological revolution, remaining vivid as each brave new world fades and disappears.

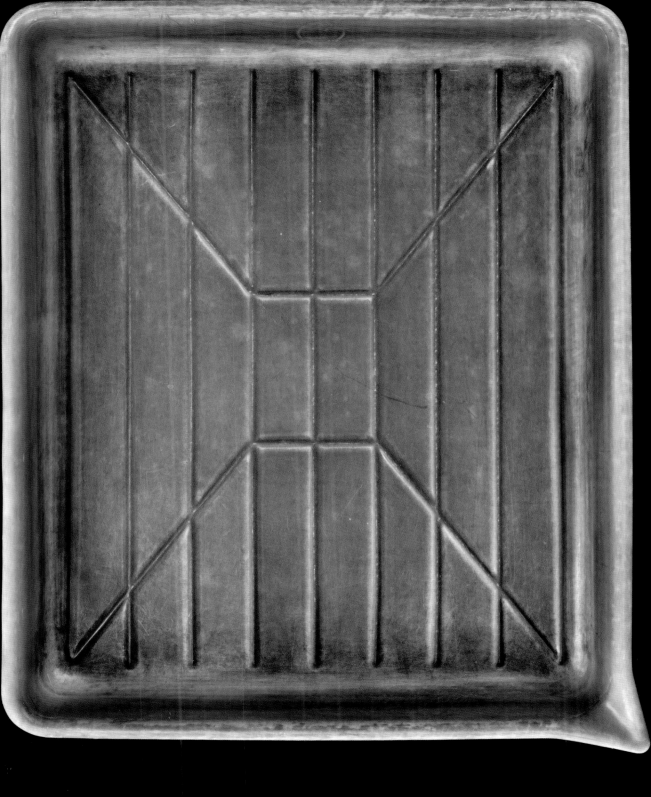

Ansel Adams

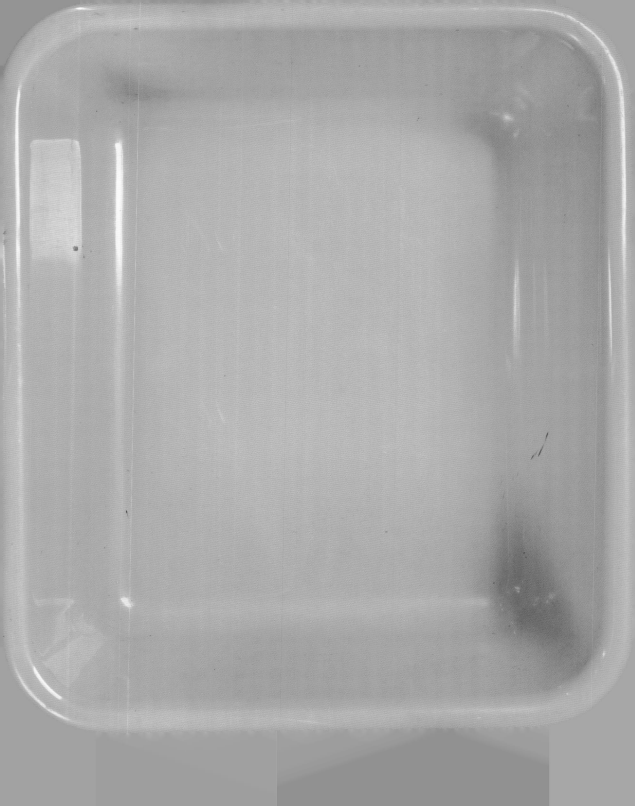

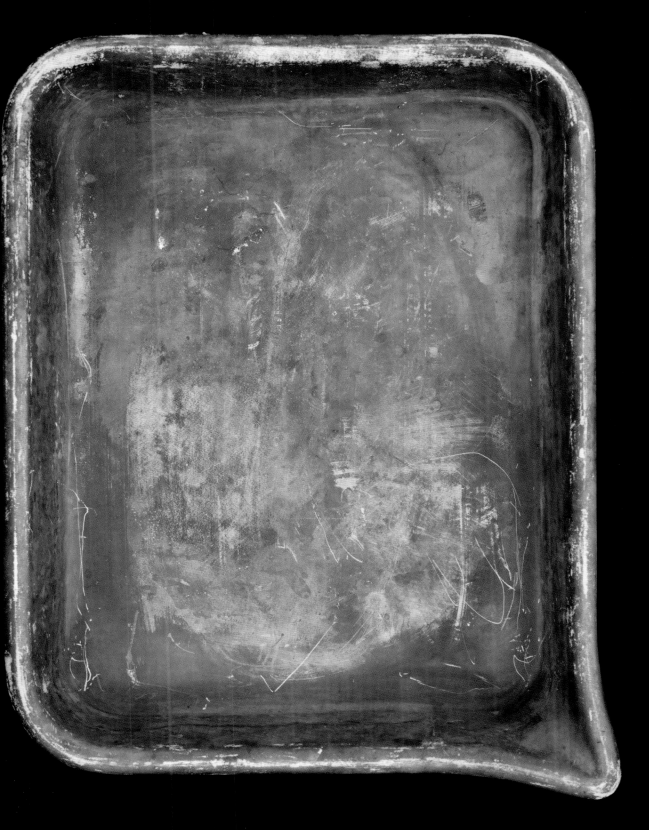

Tom Baril

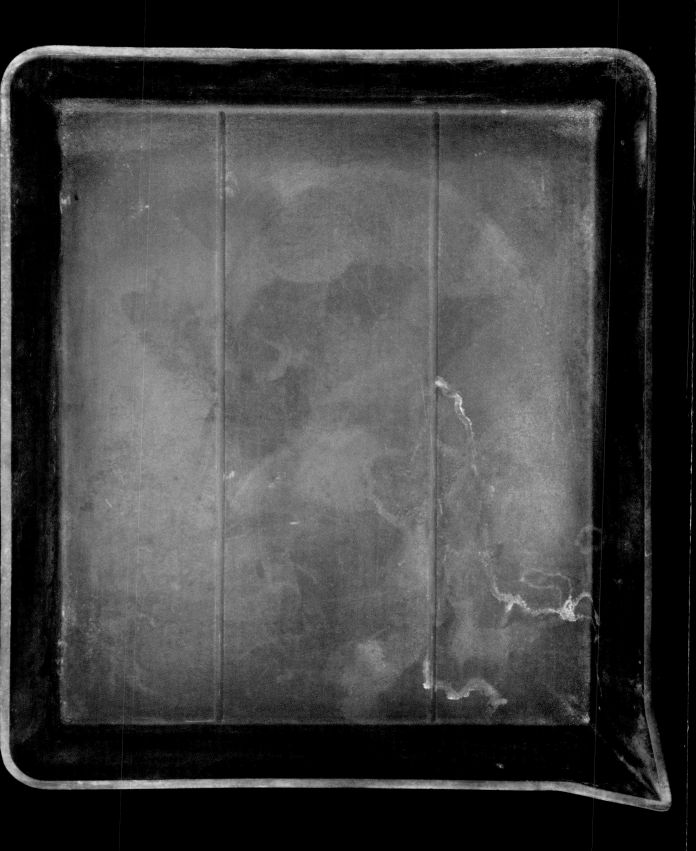

Lillian Bassman

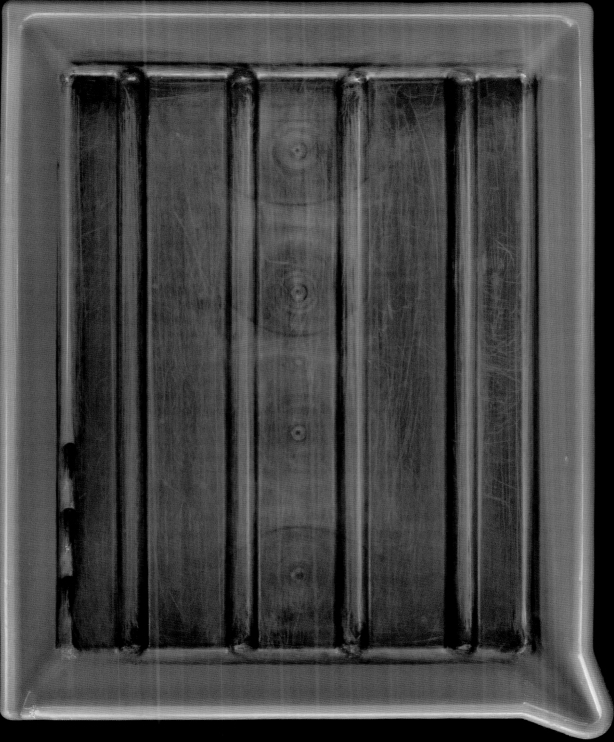

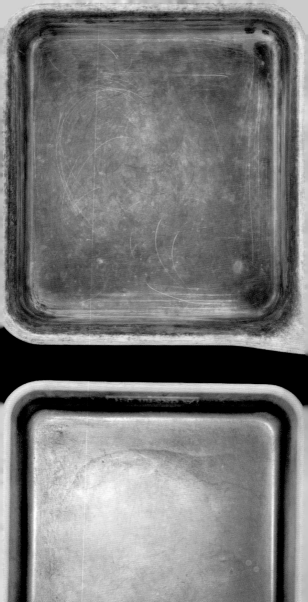
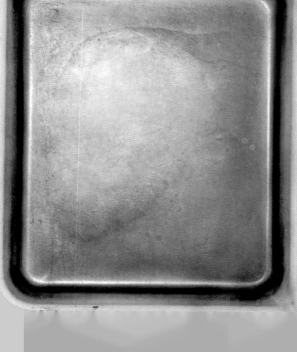

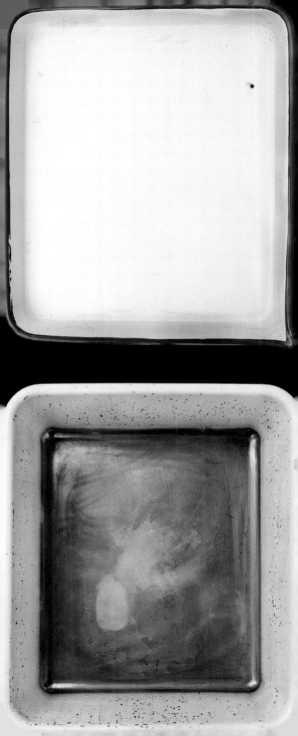

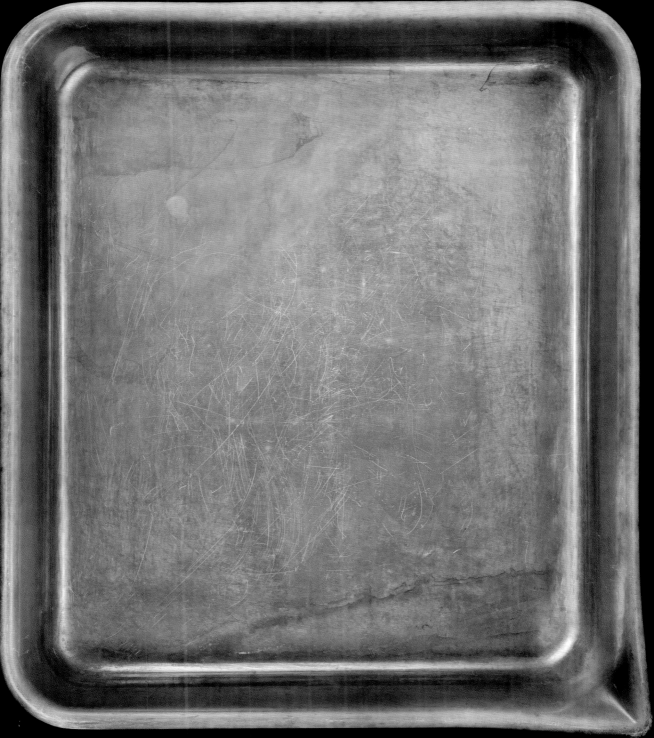

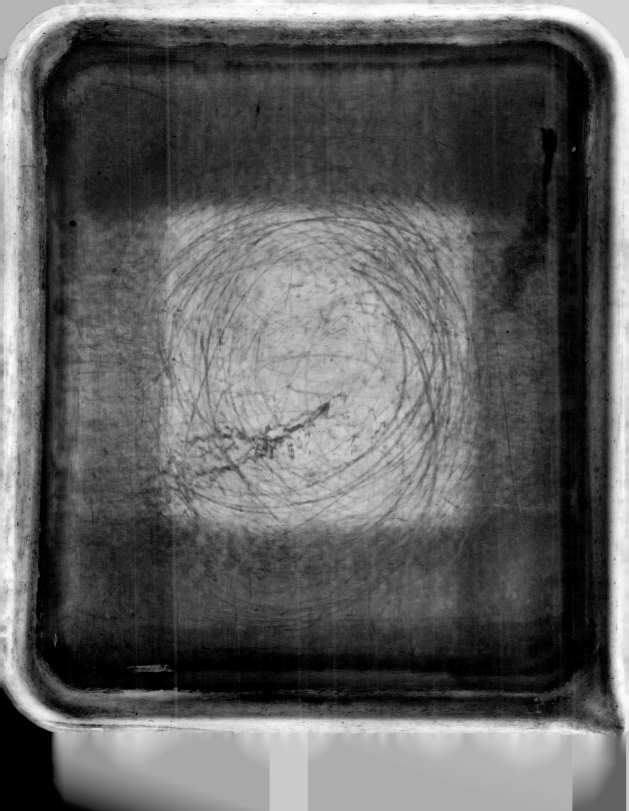

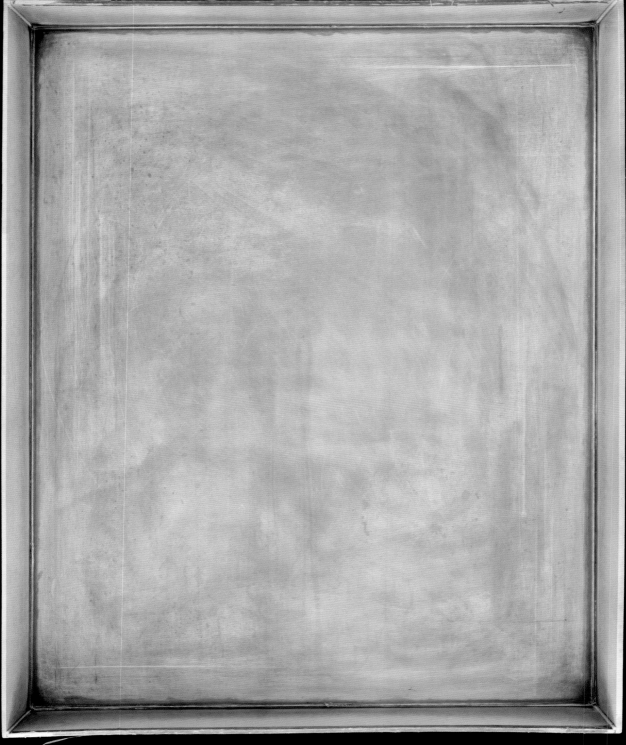

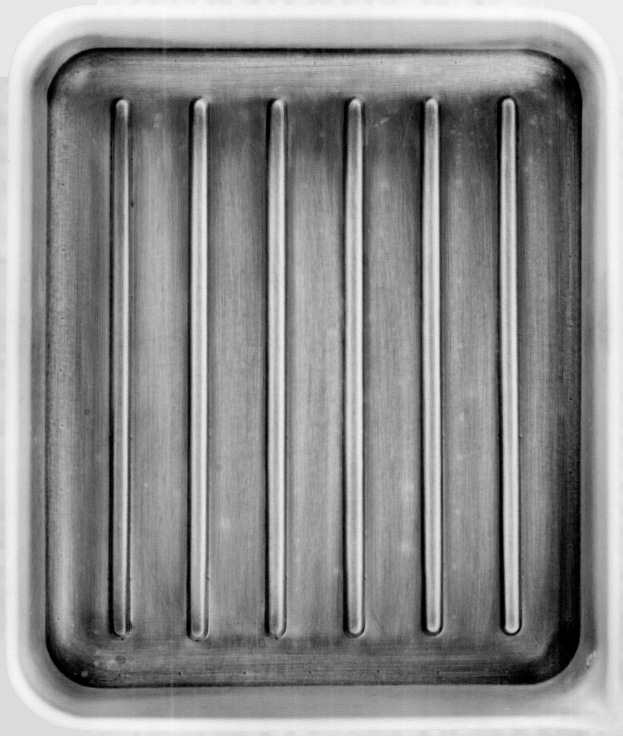

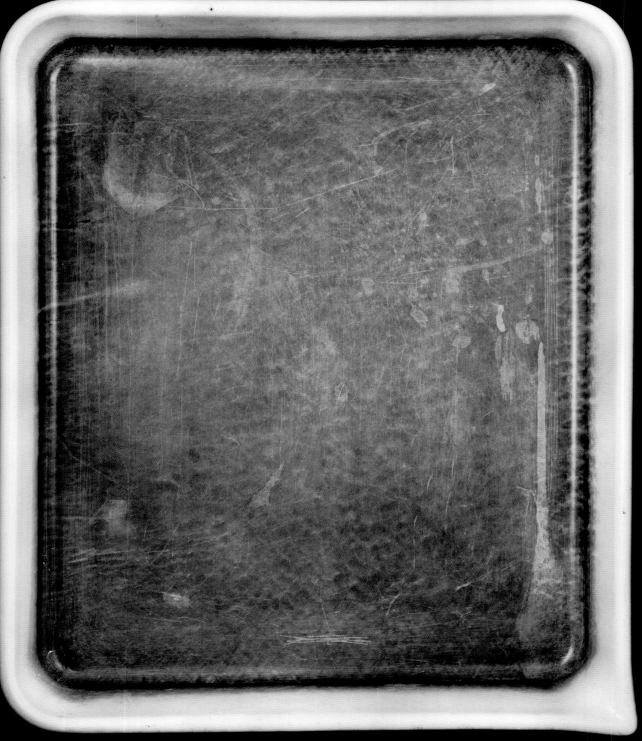

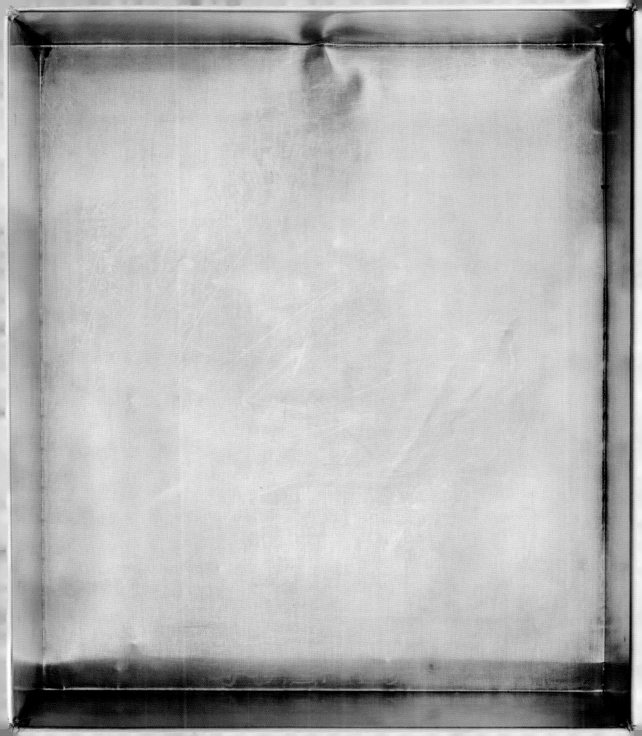

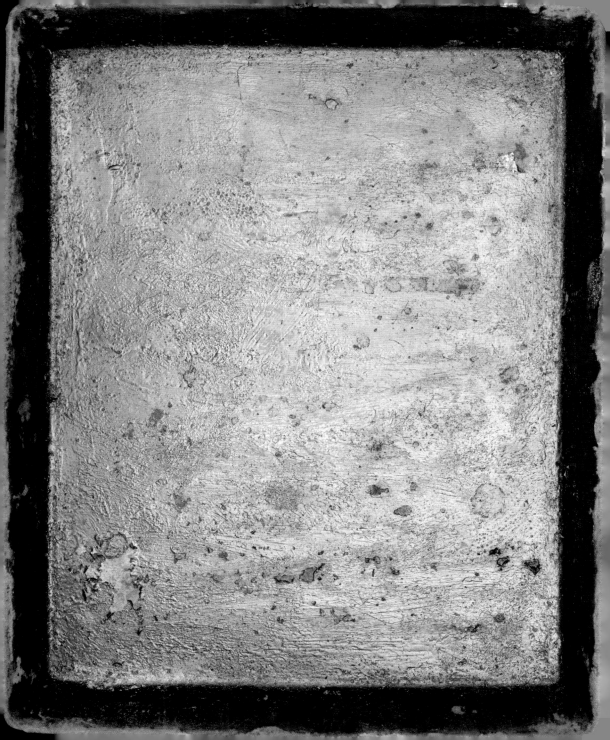

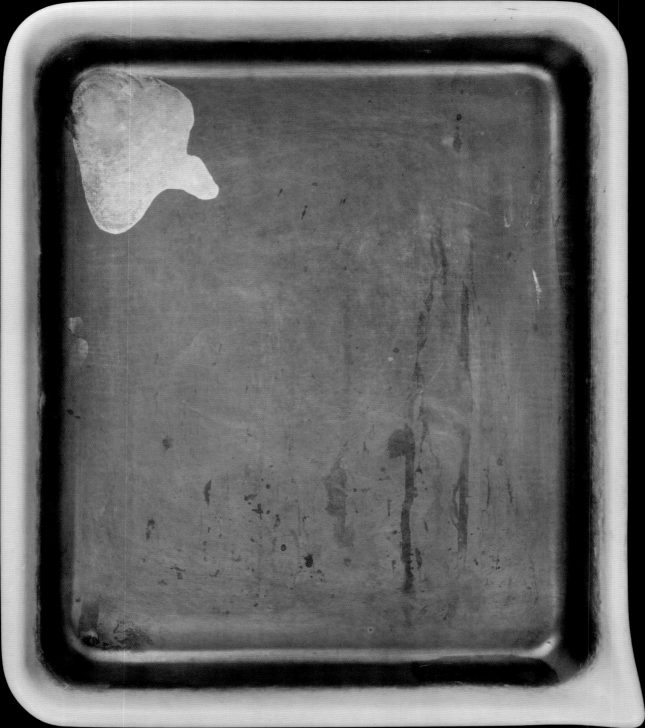

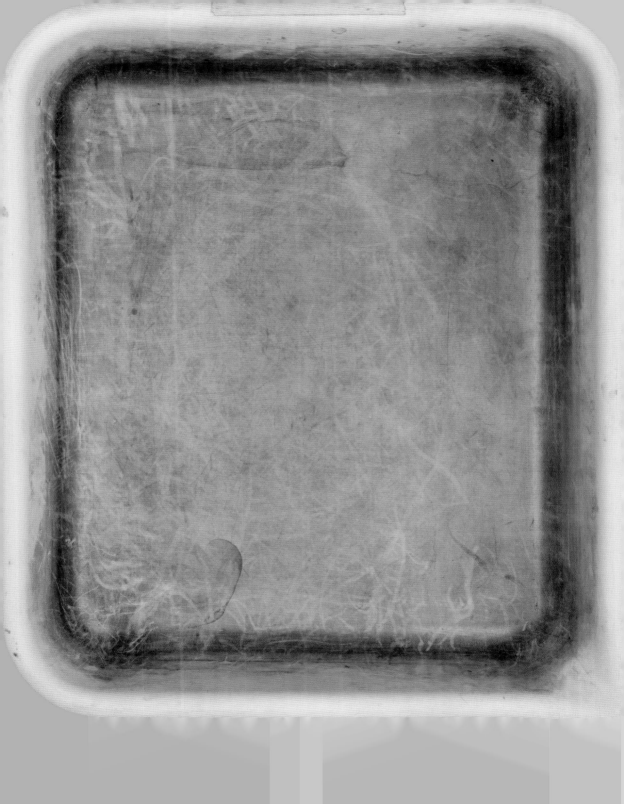

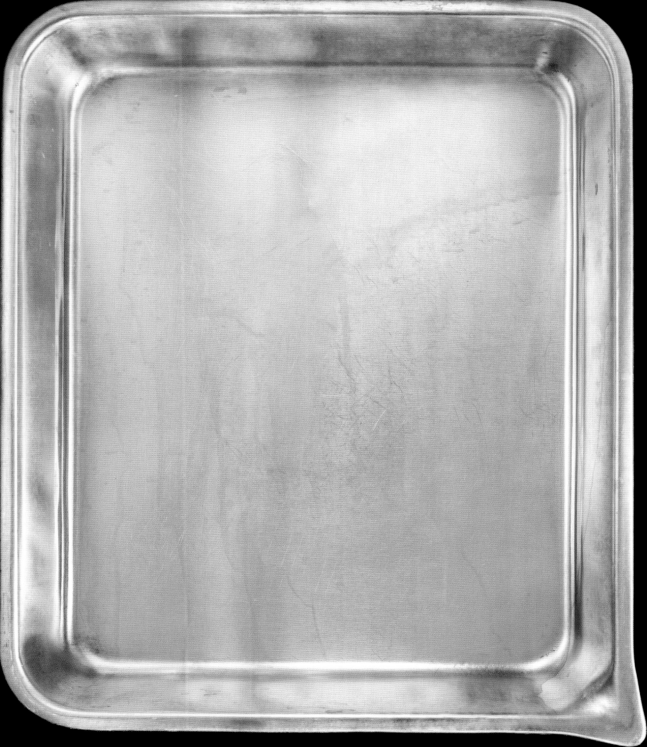

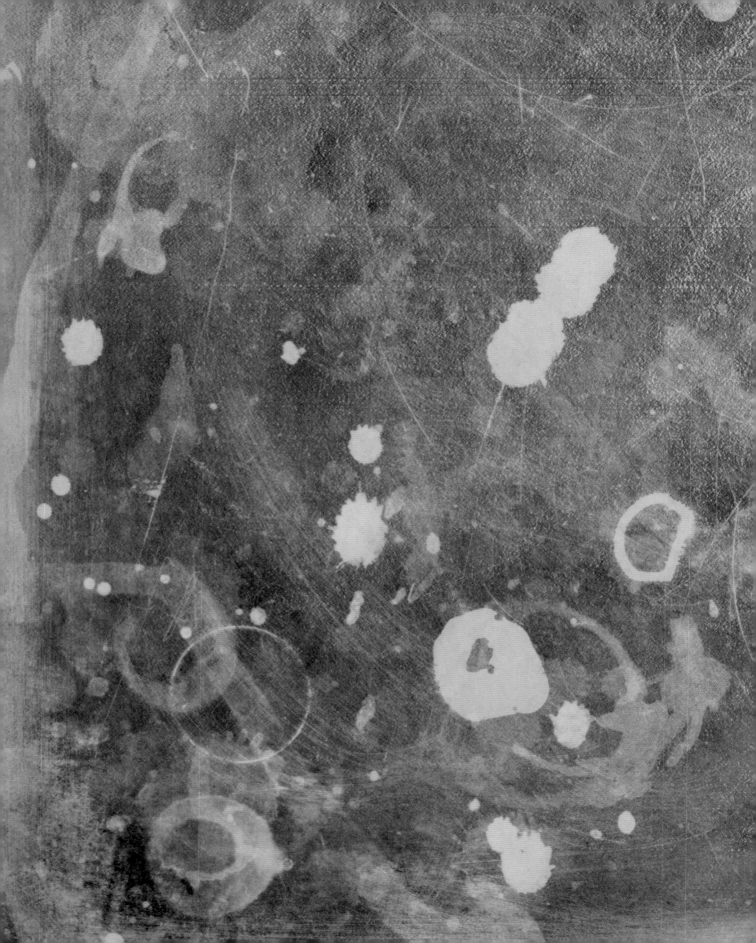

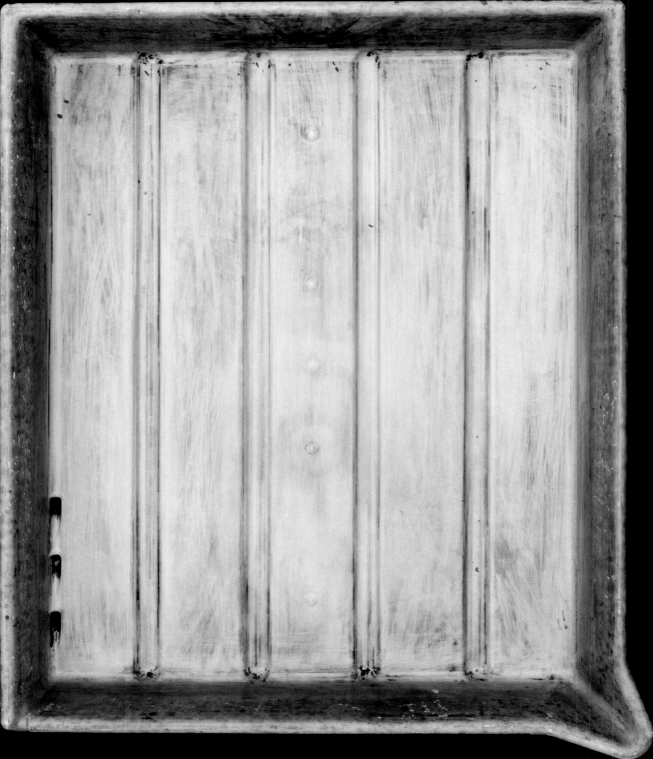

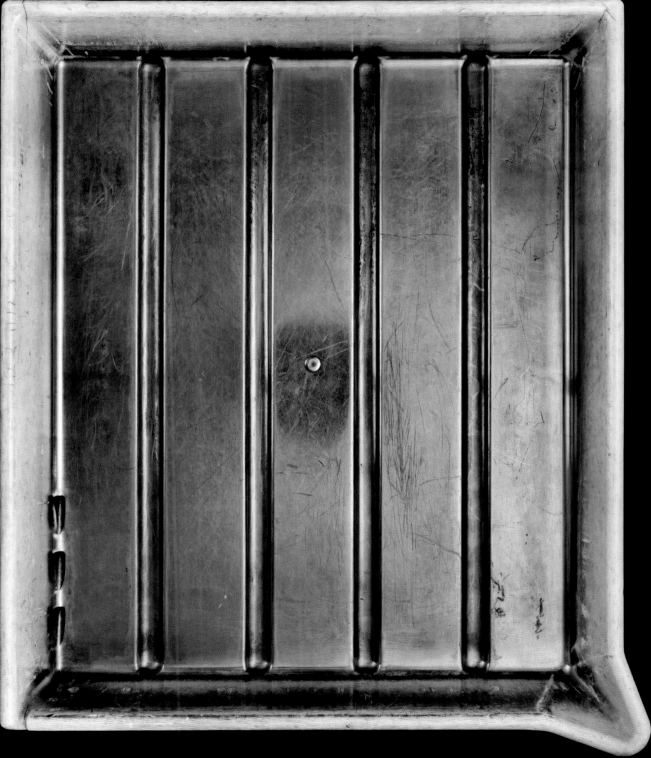

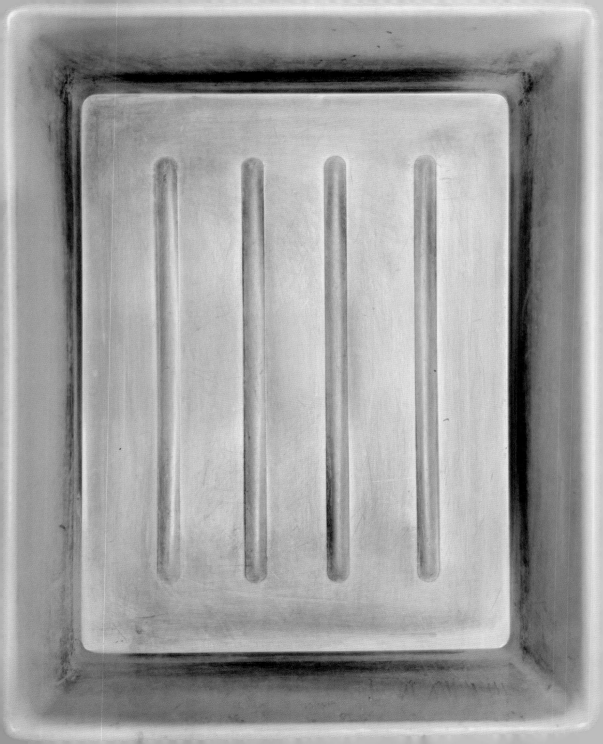

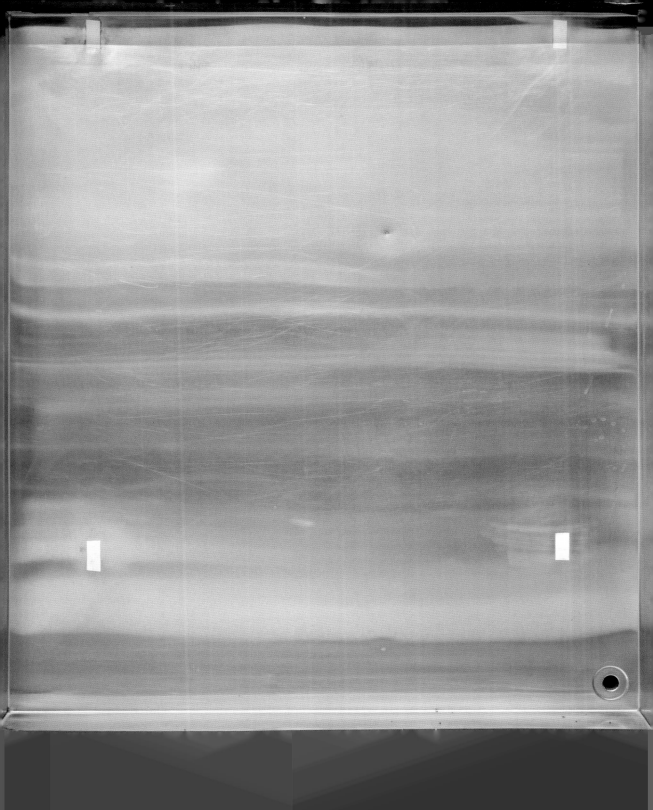

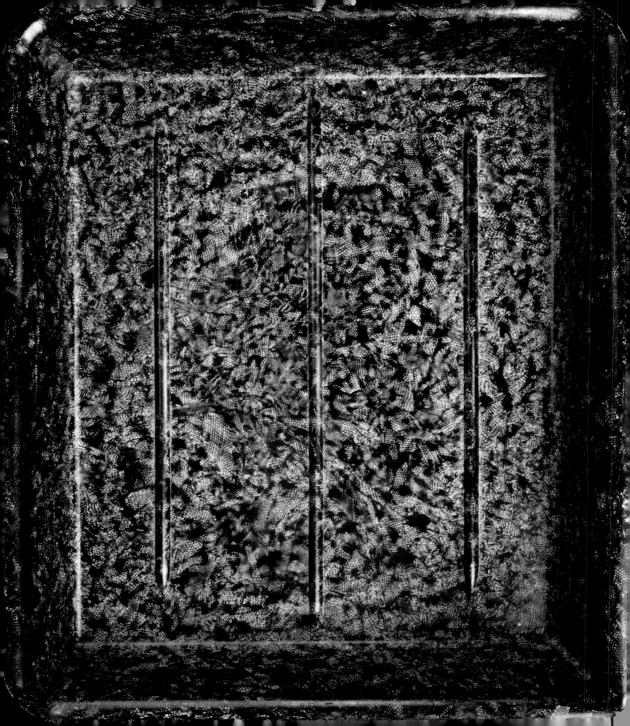

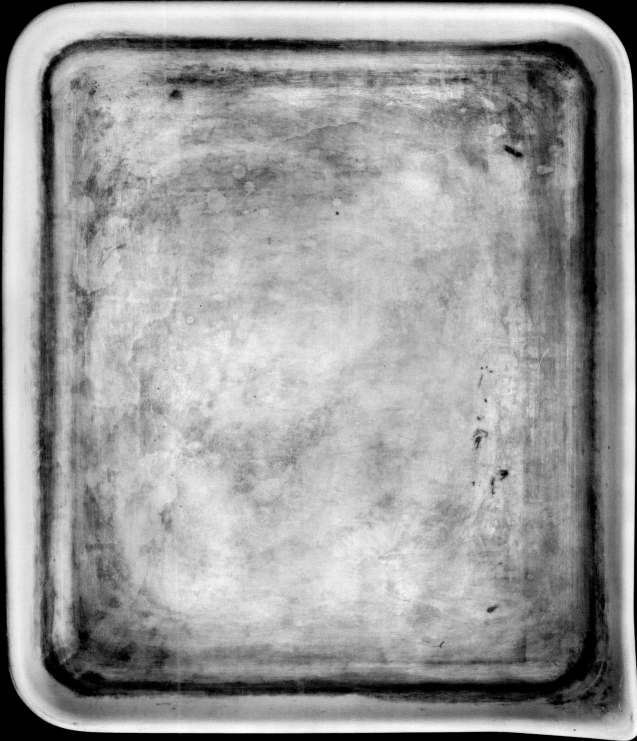

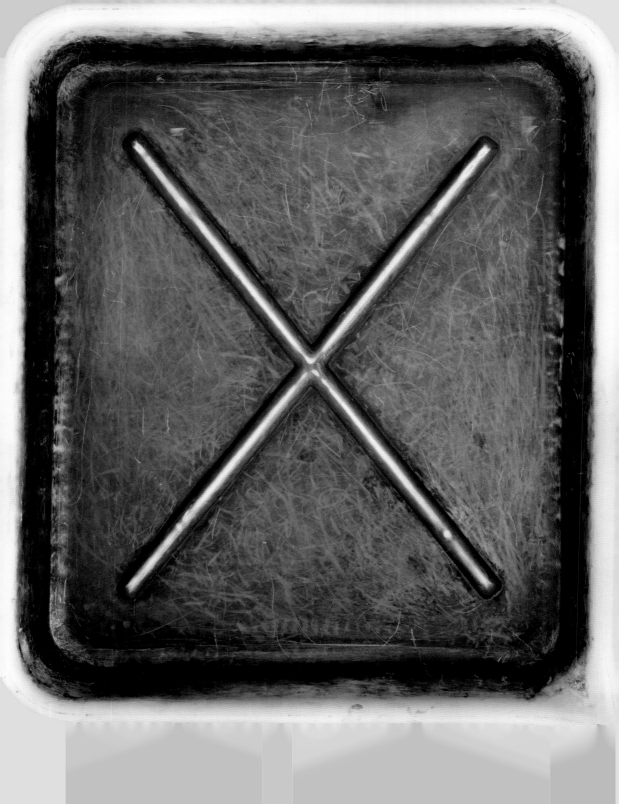

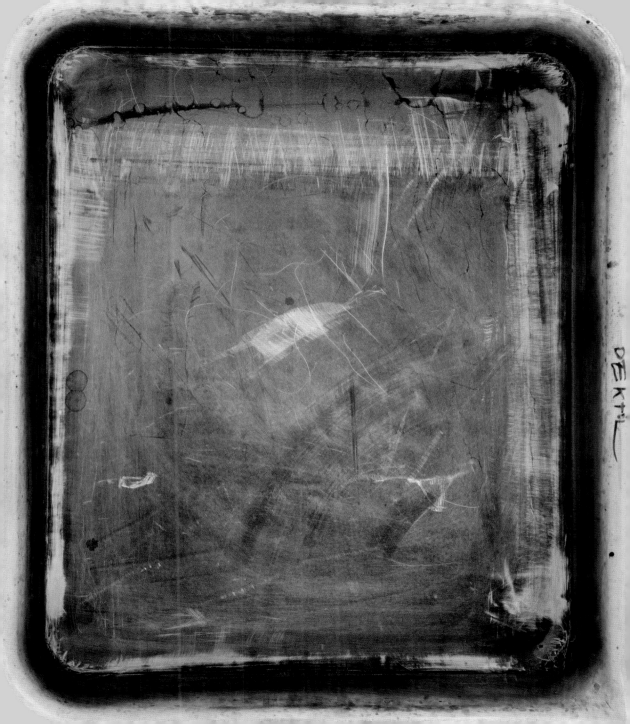

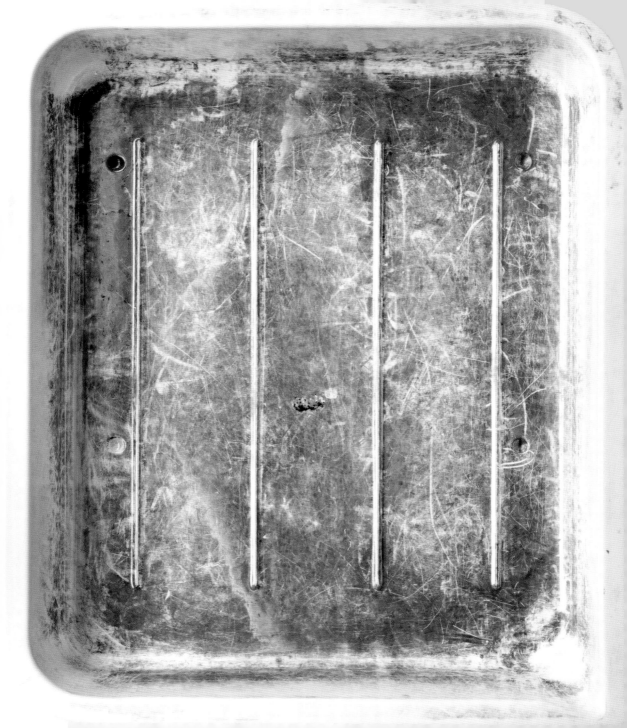

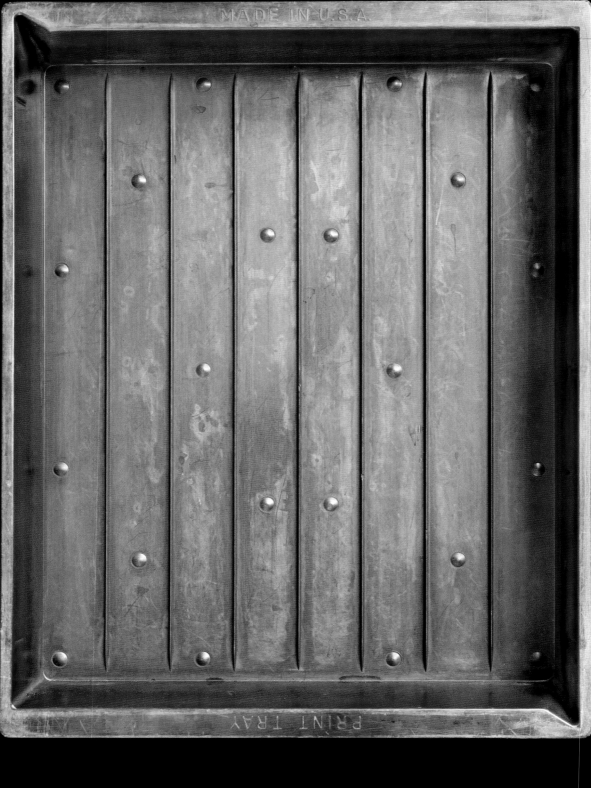

Ed Grazda

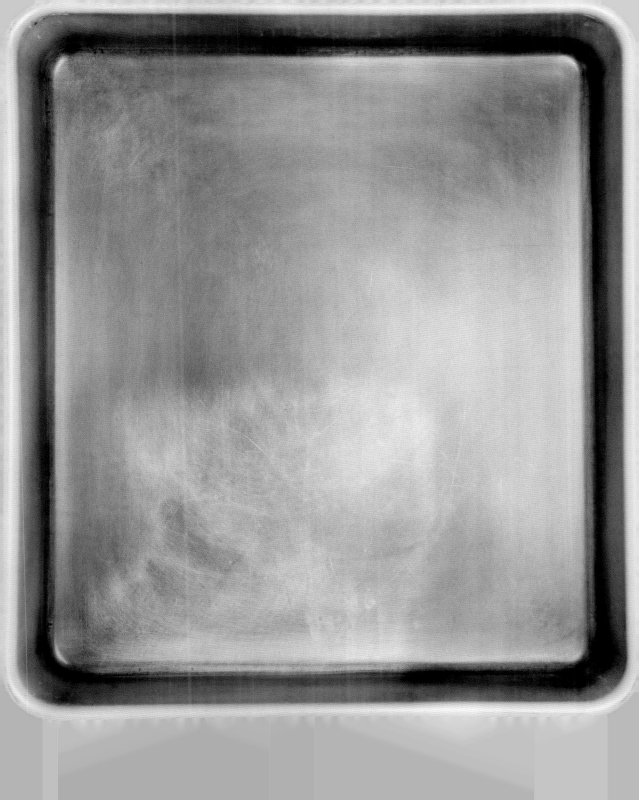

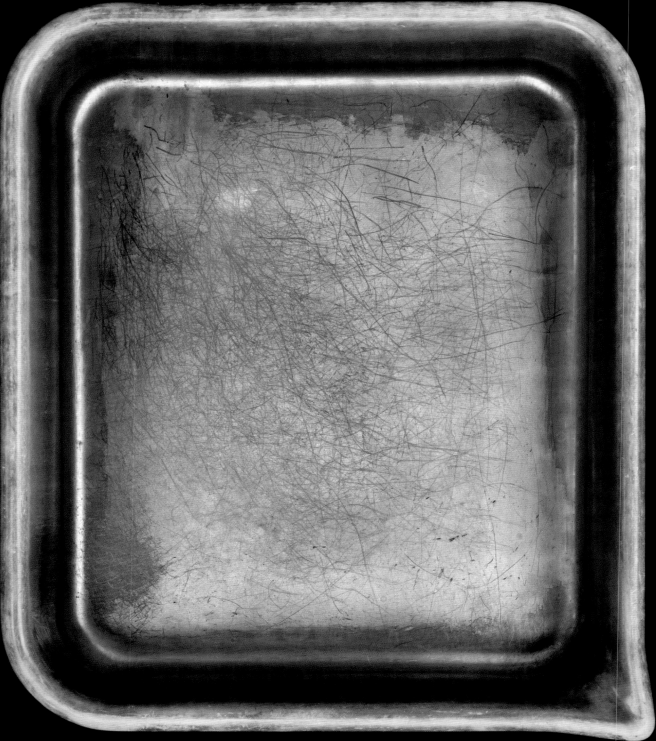

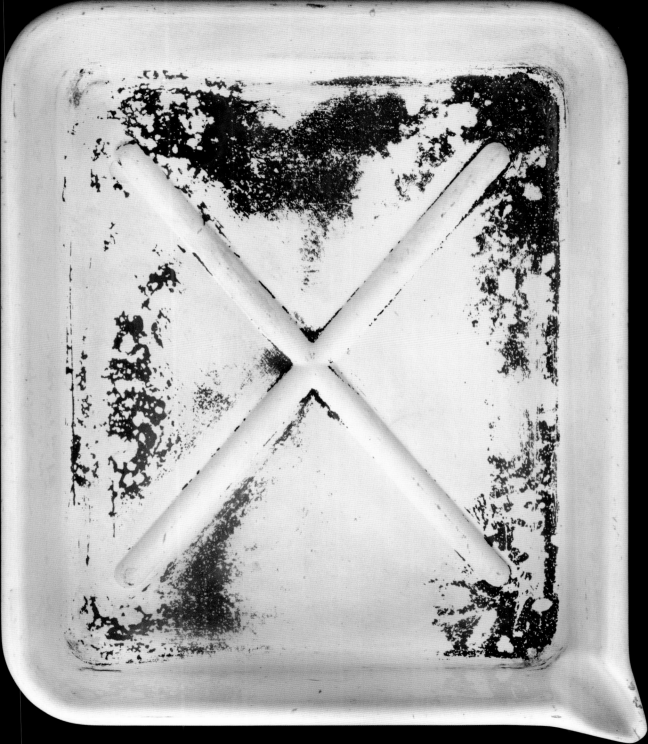

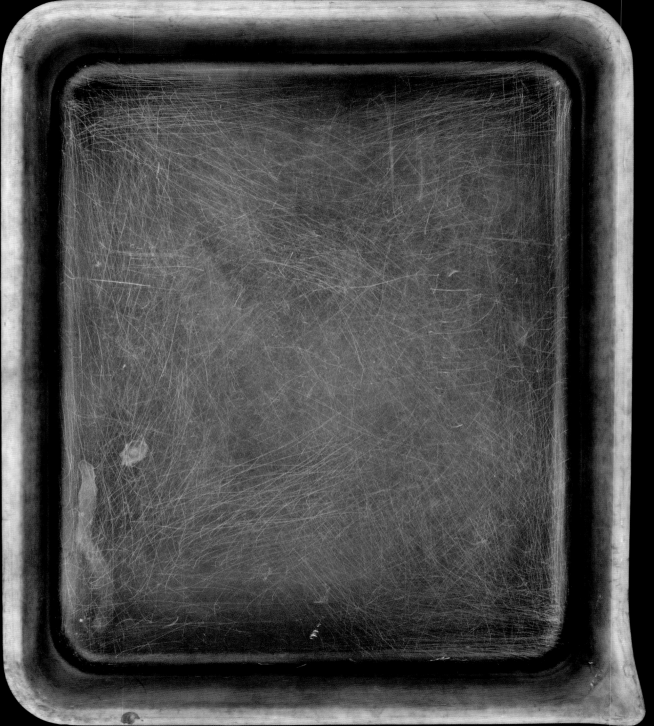

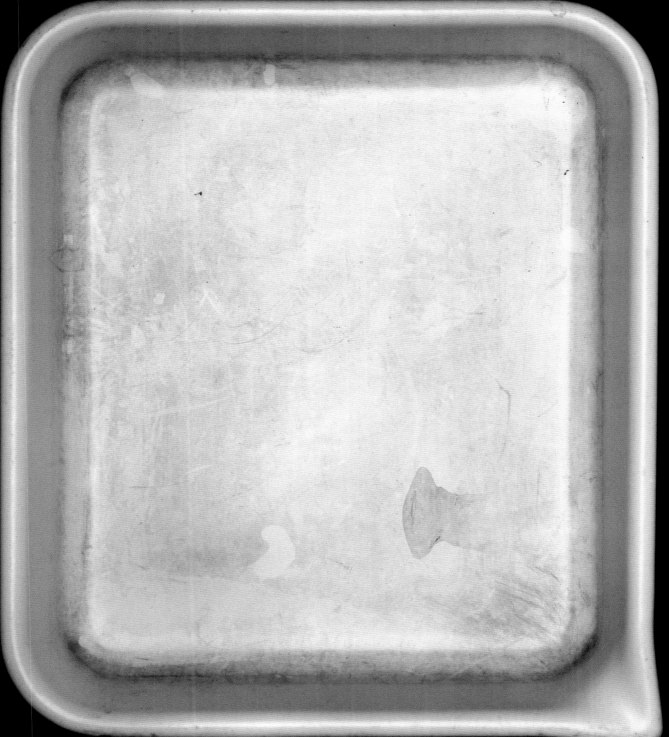

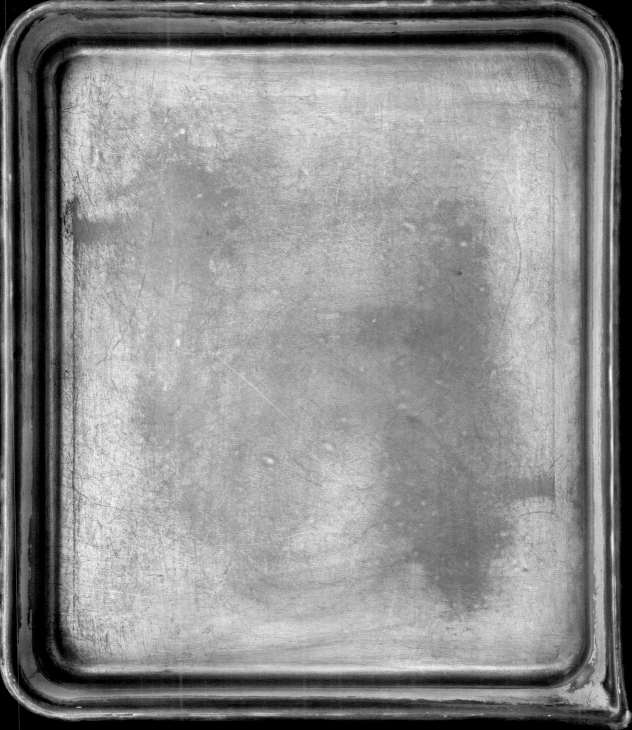

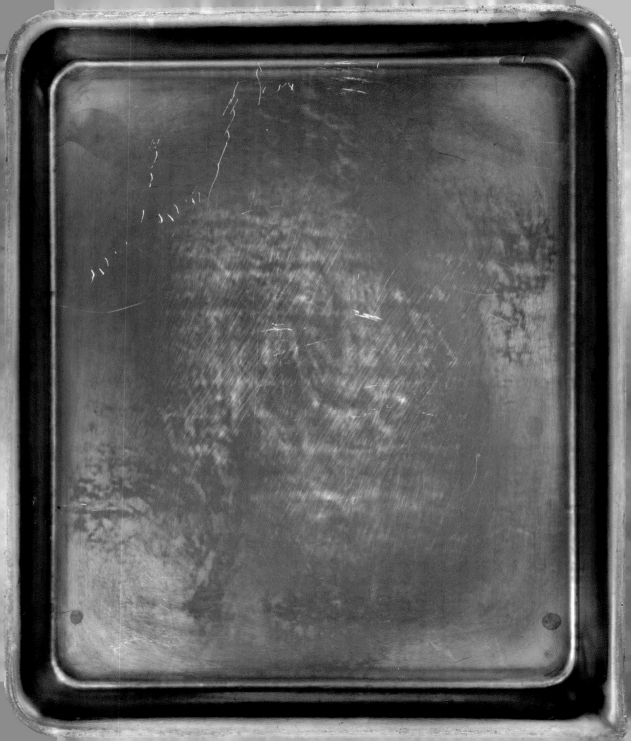

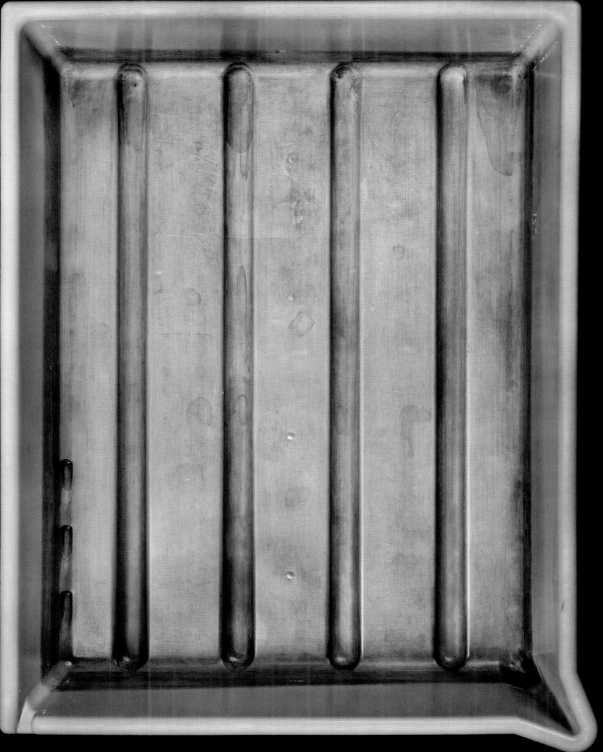

F.J. COX,
26, LUDGATE HILL,
LONDON.

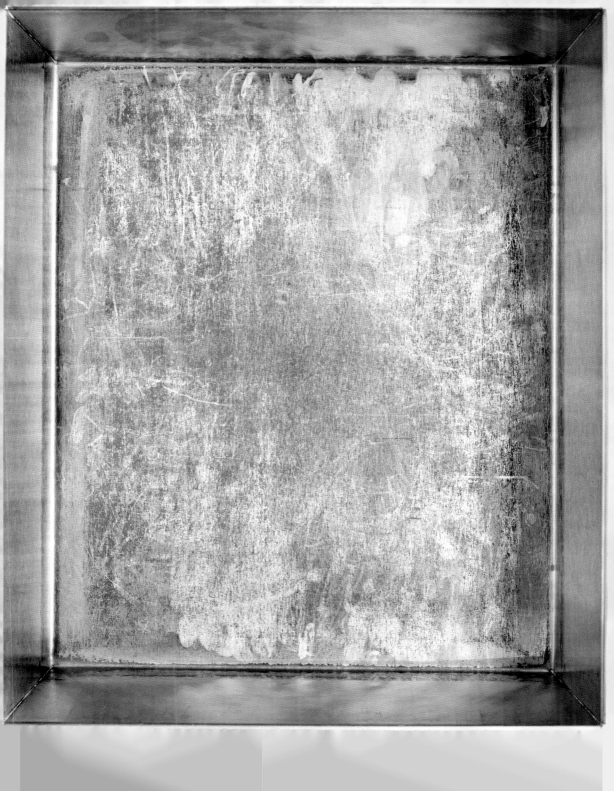

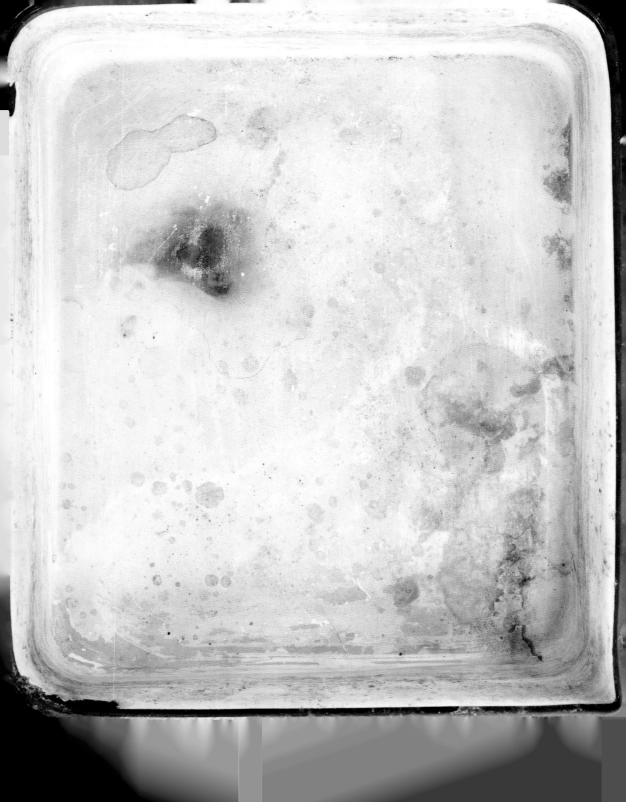

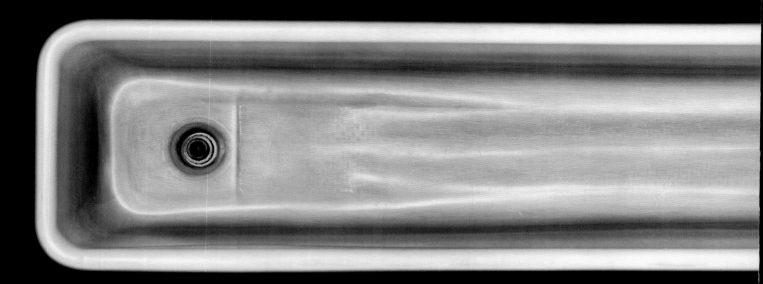

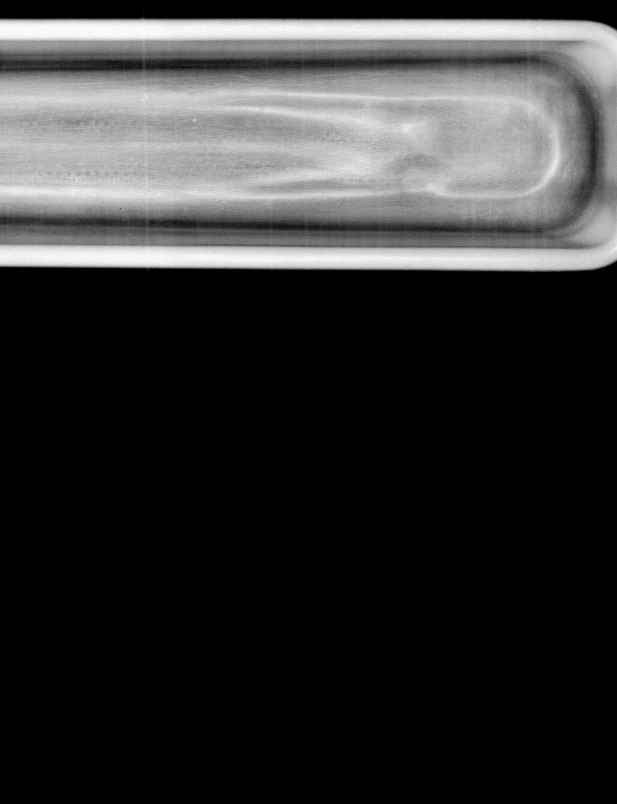

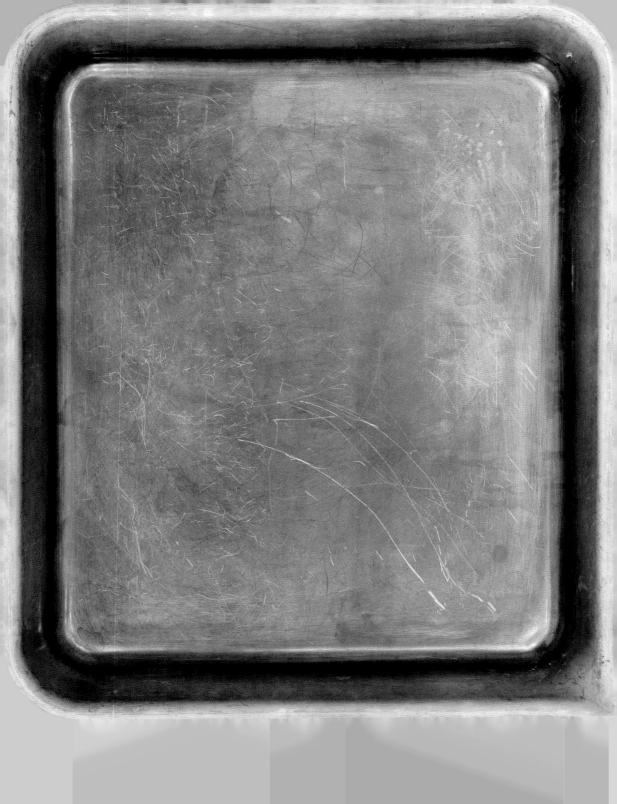

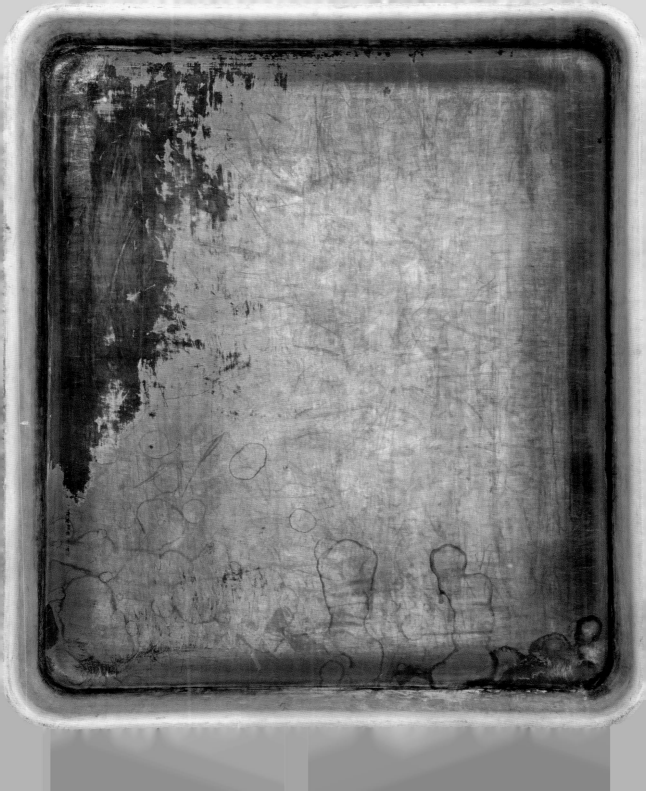

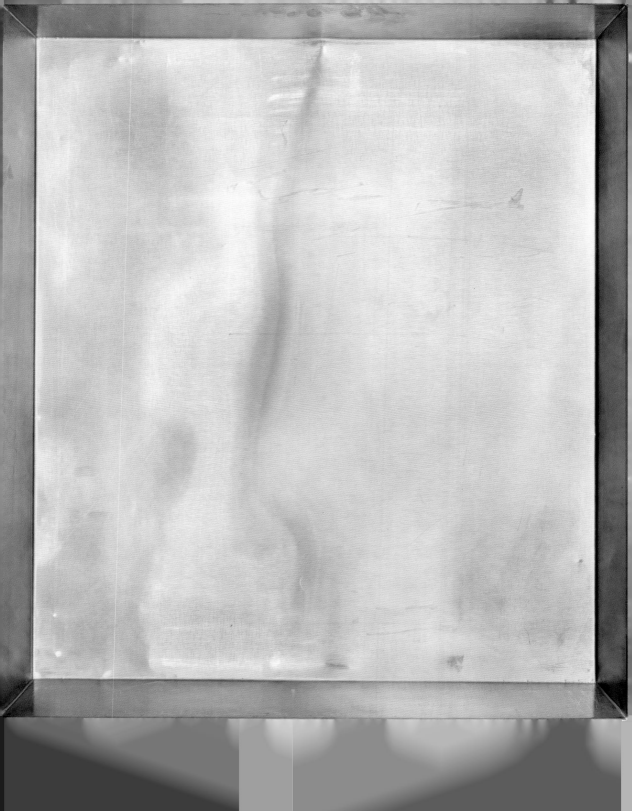

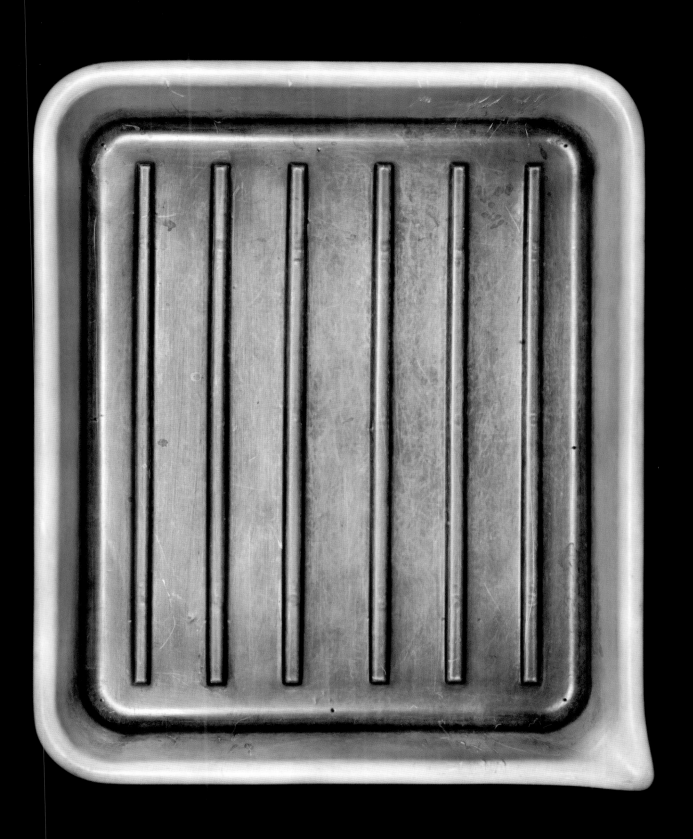

Chris McCaw

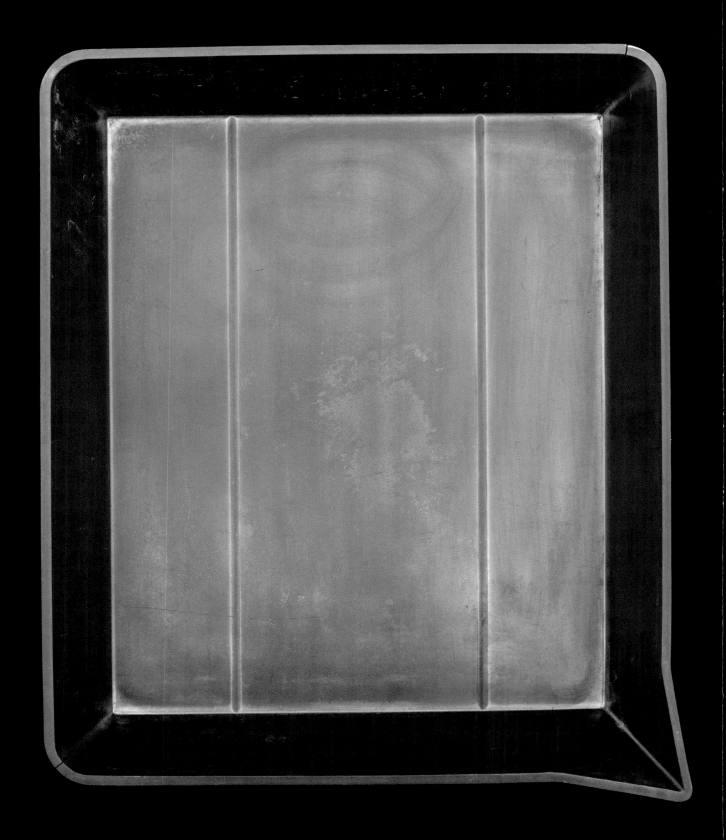

Amanda Means

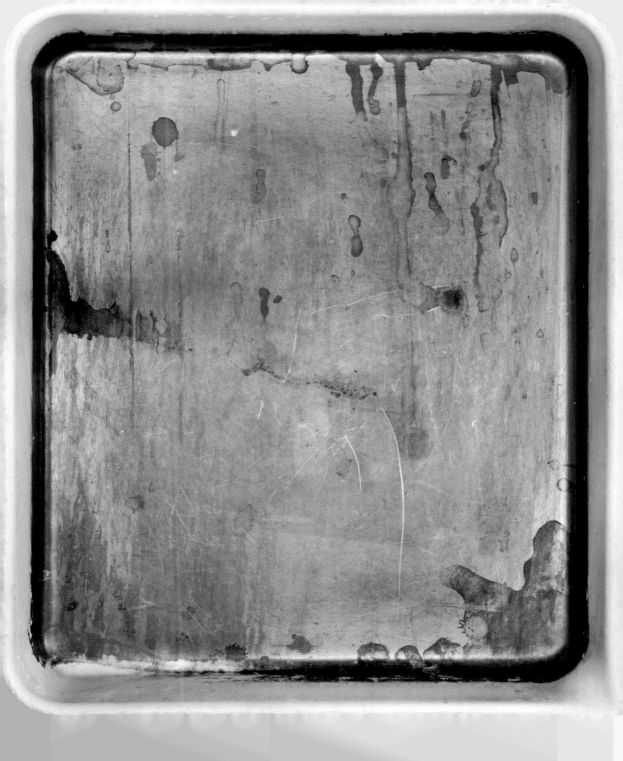

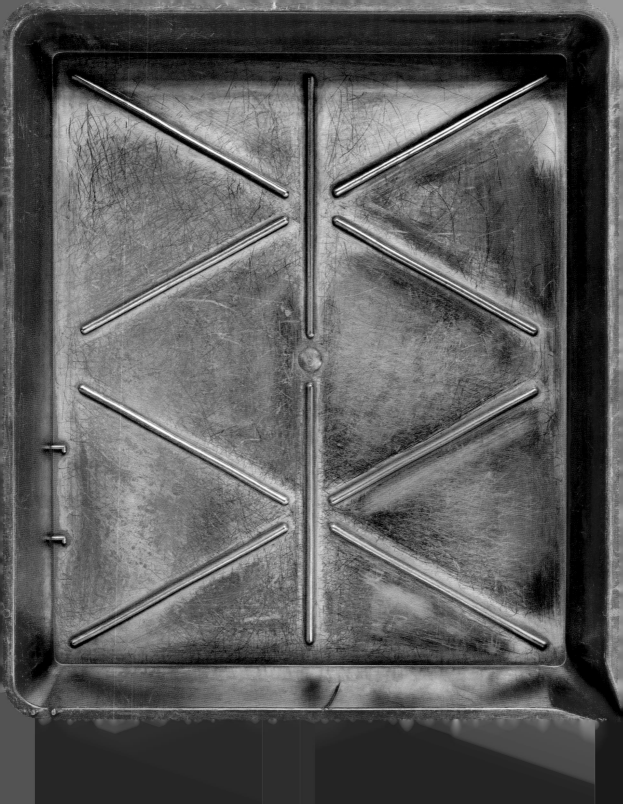

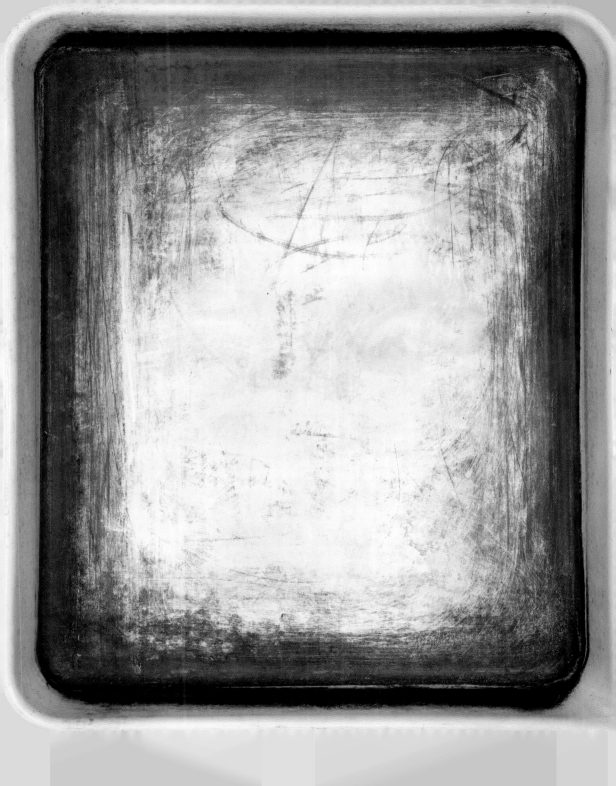

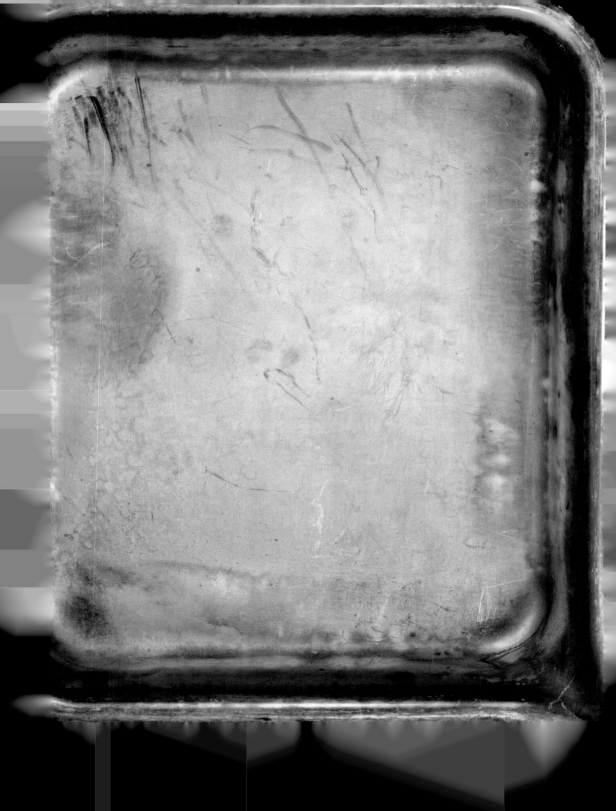

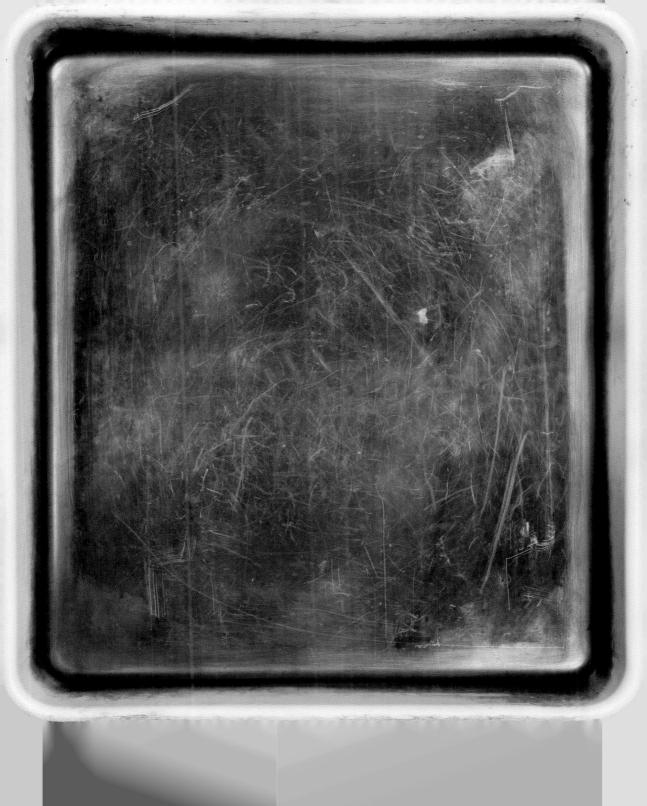

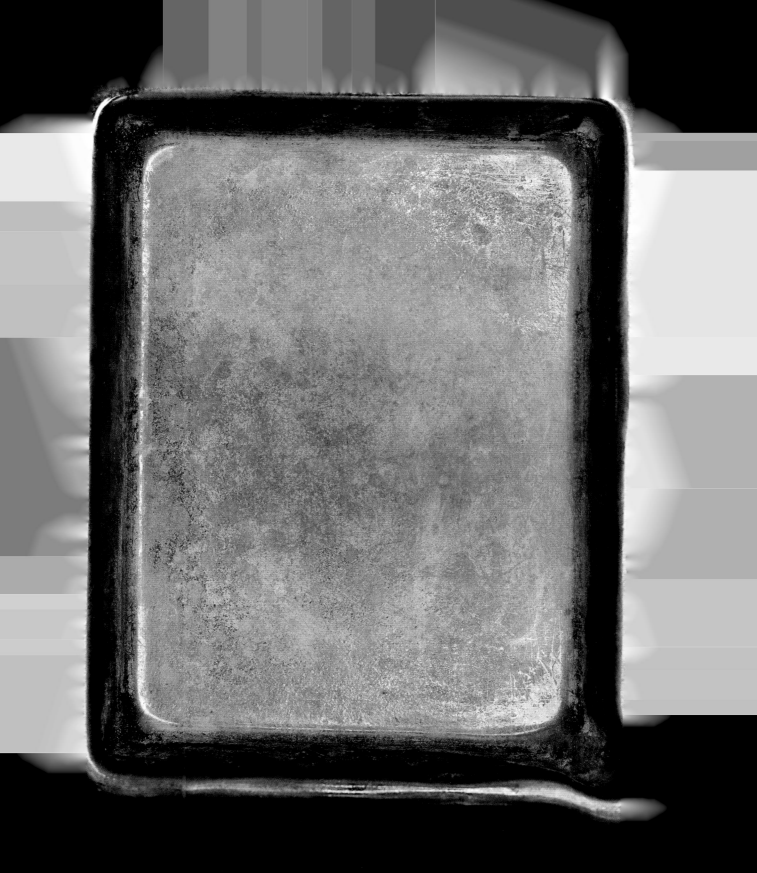

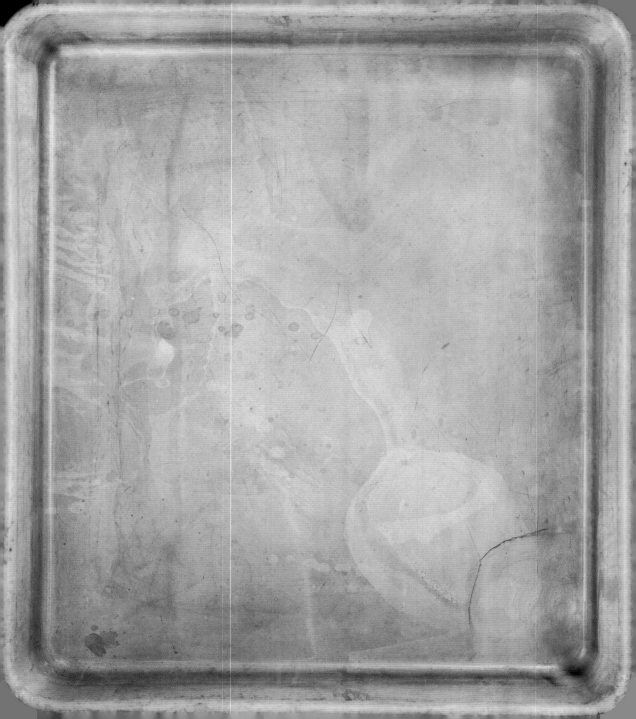

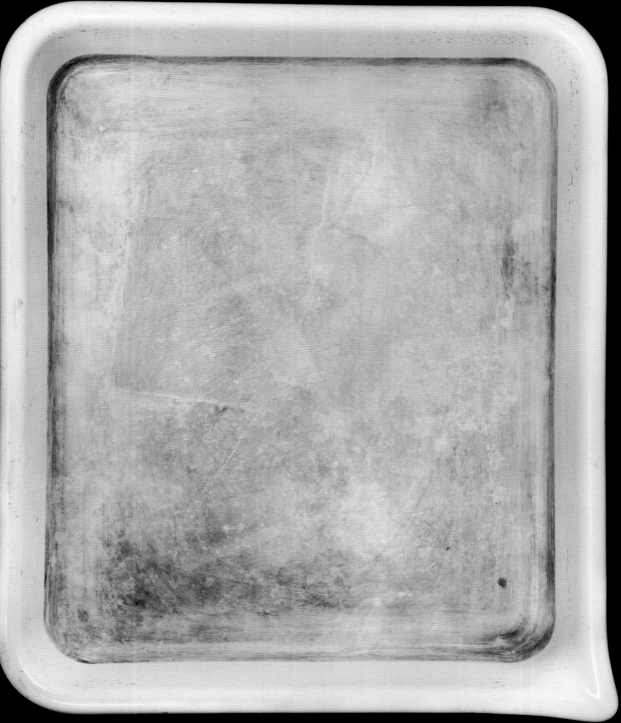

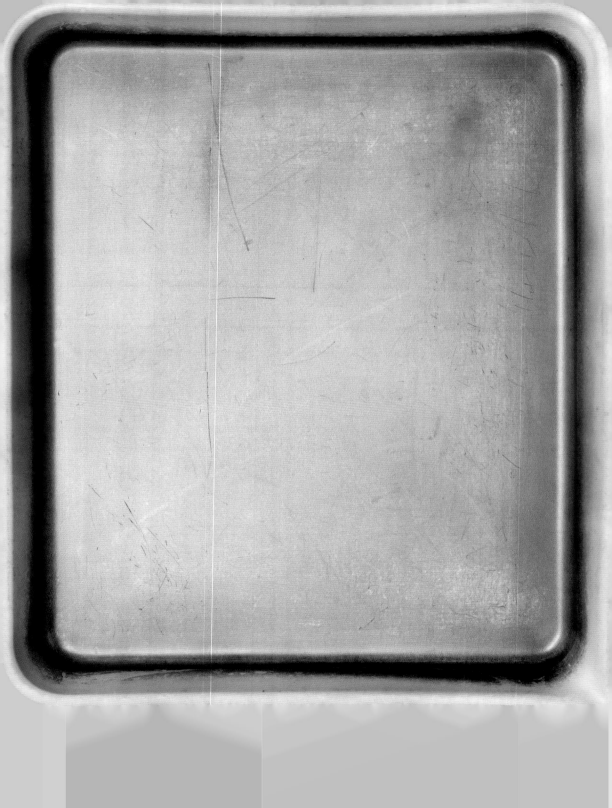

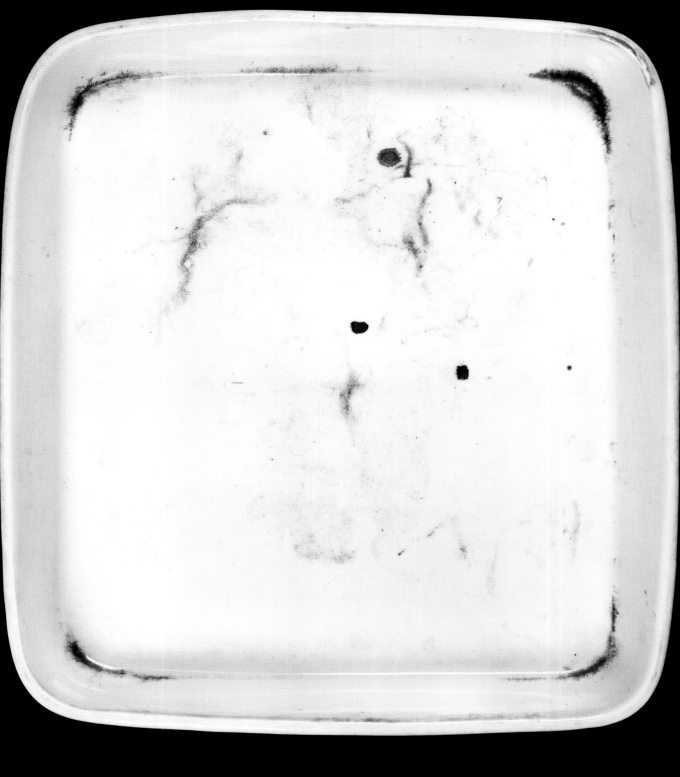

The Photo Studio of the American Museum
of Natural History

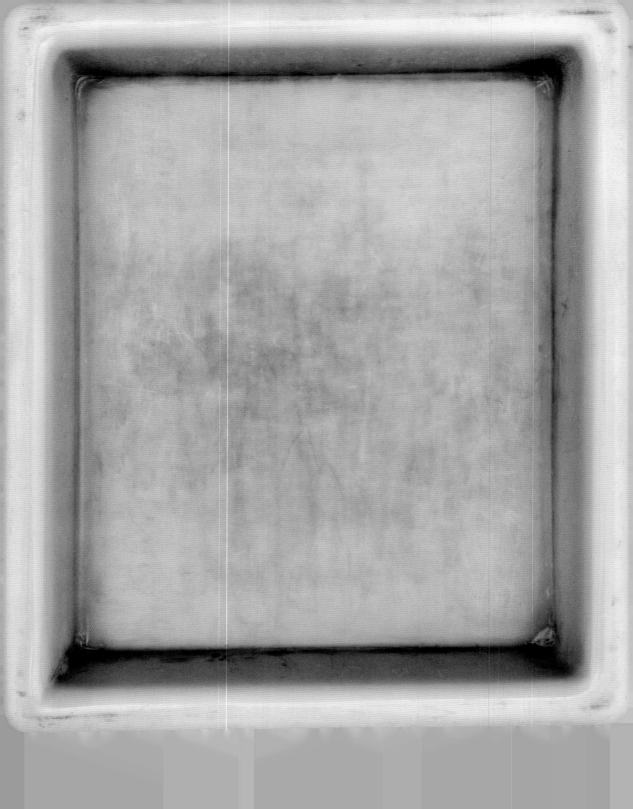

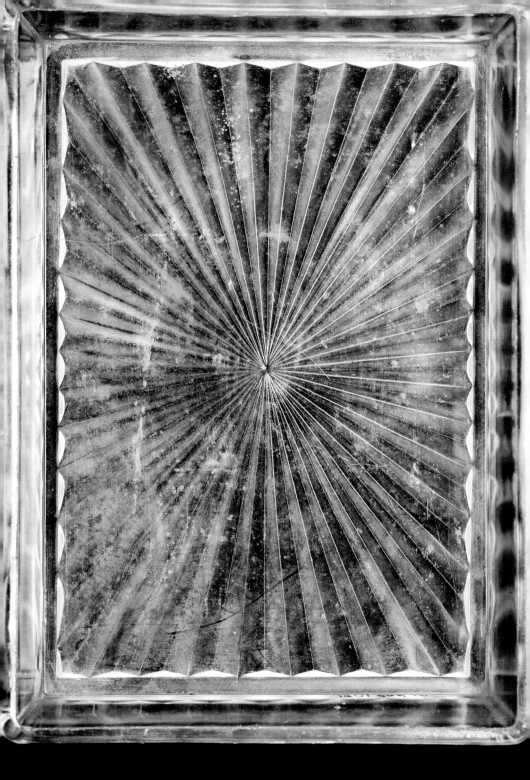

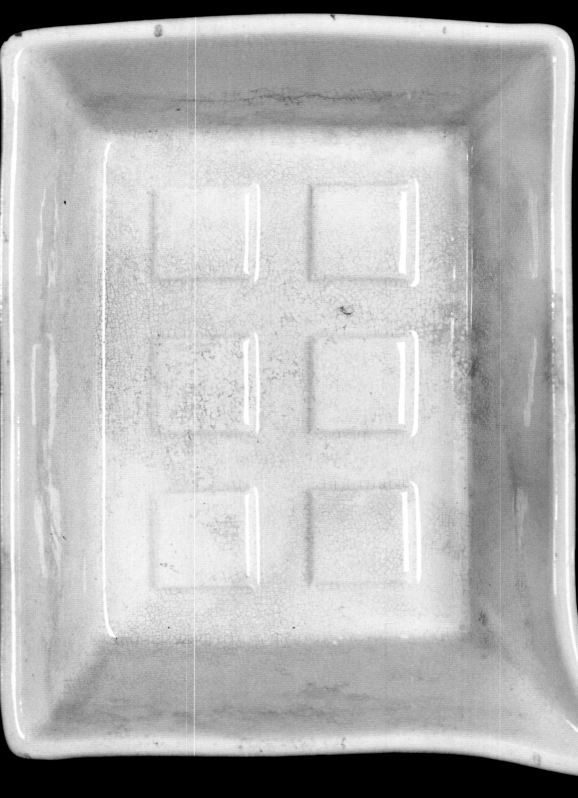

The Photographic History Collection at the Smithsonian's
National Museum of American History

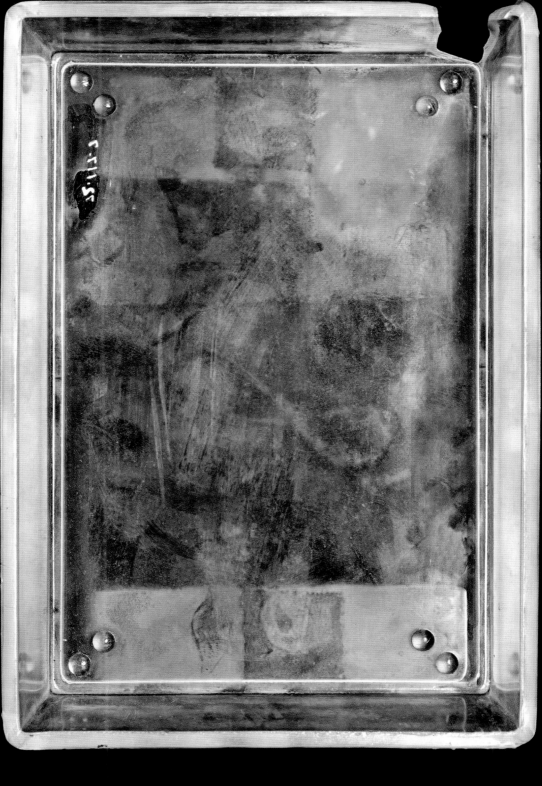

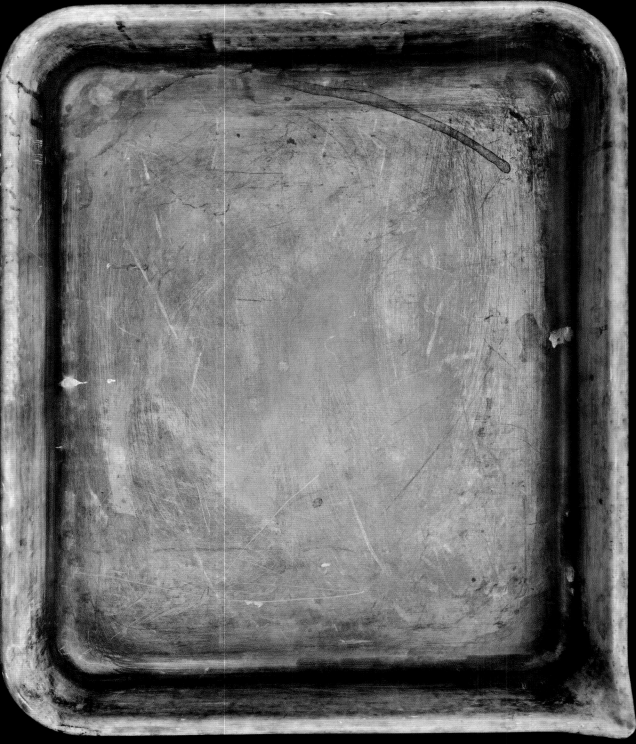

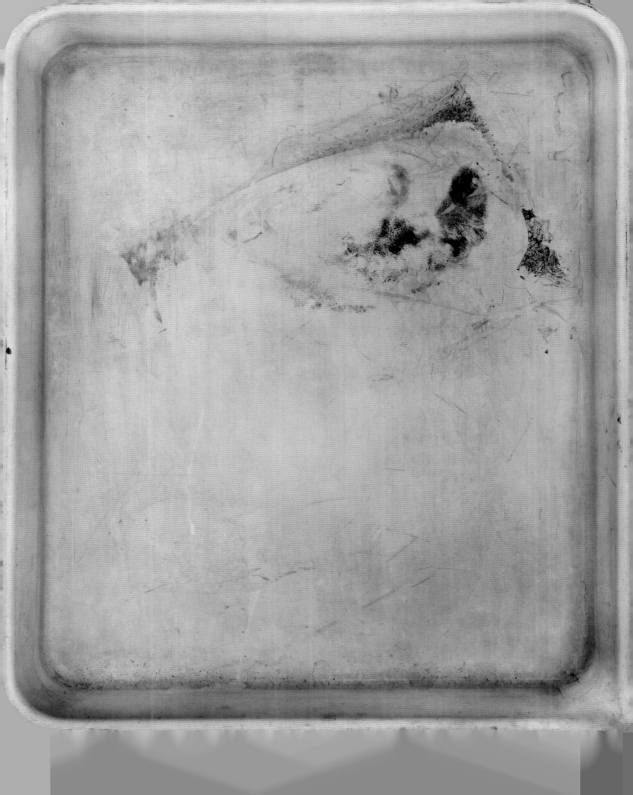

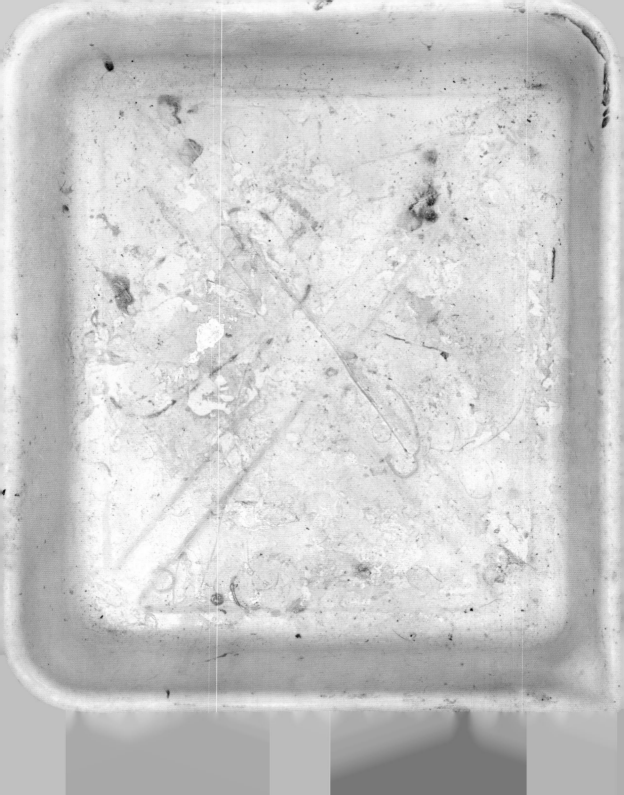

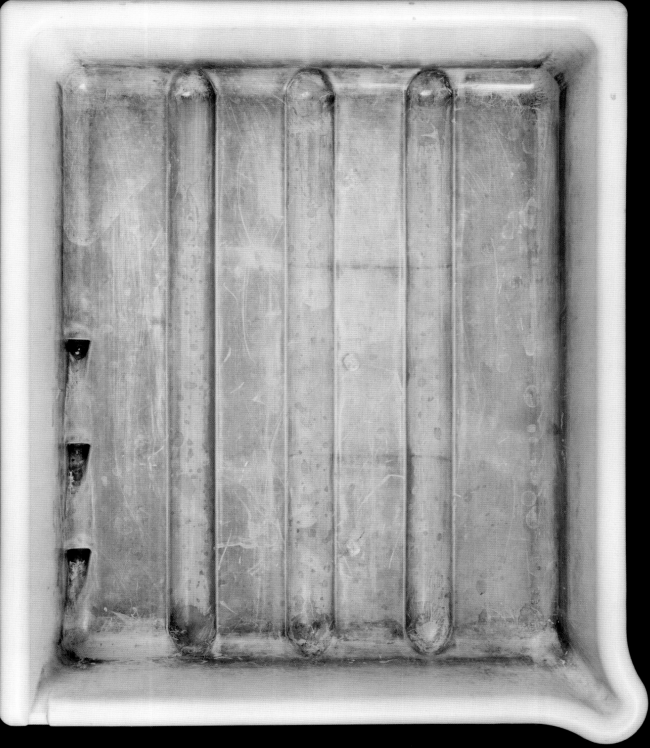

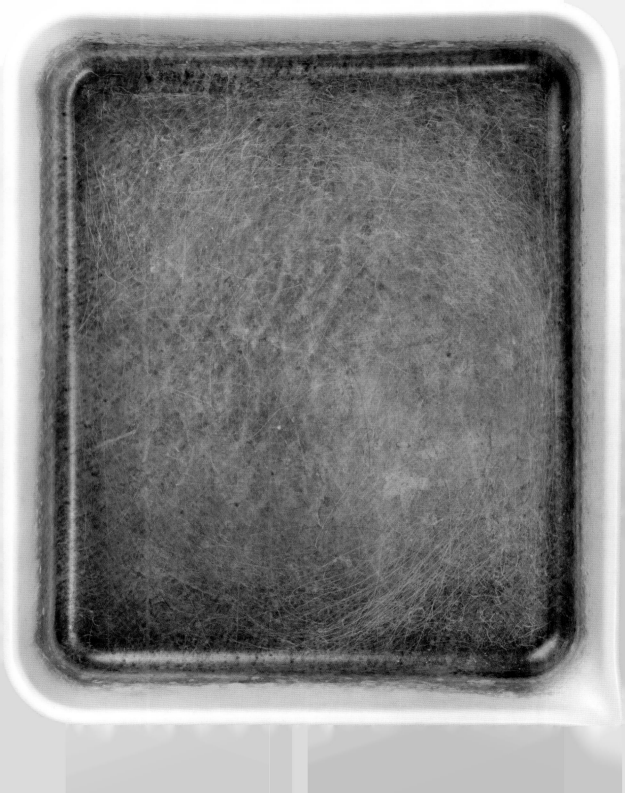

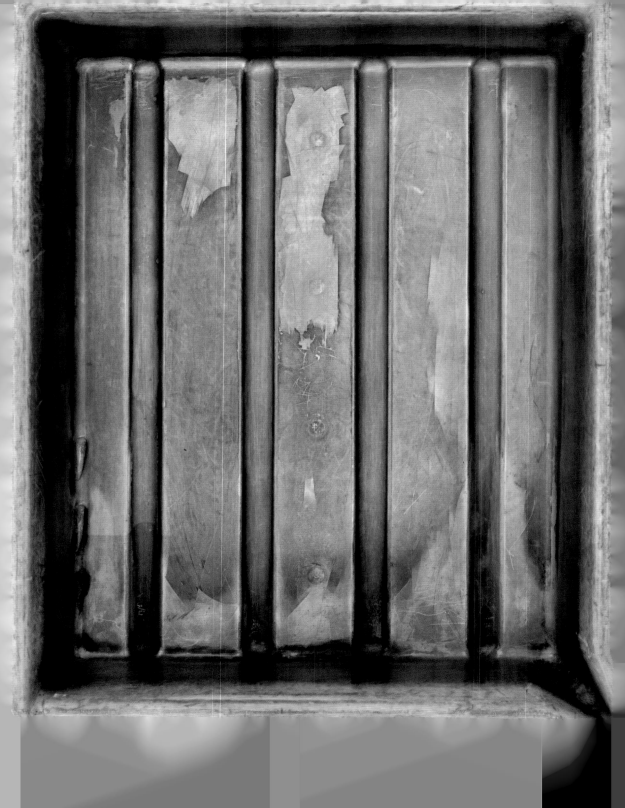

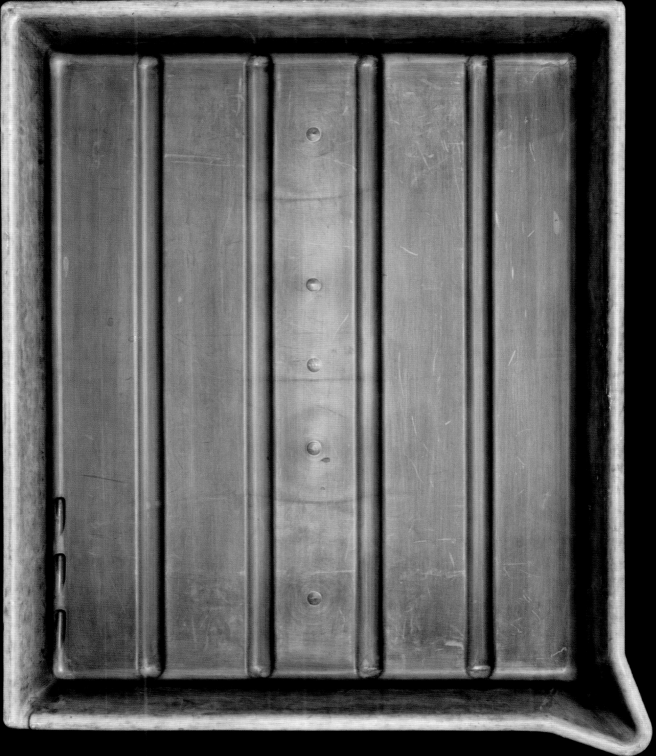

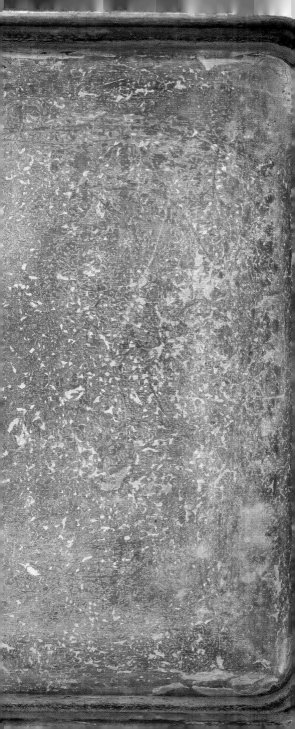

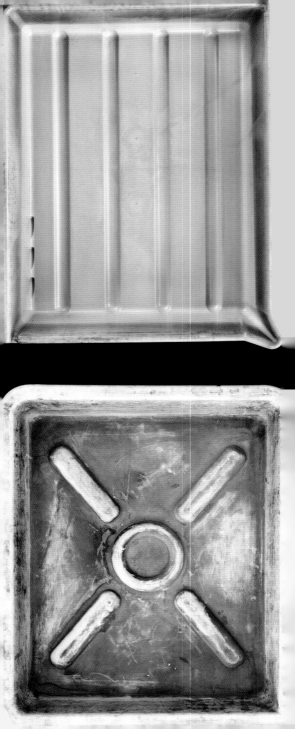

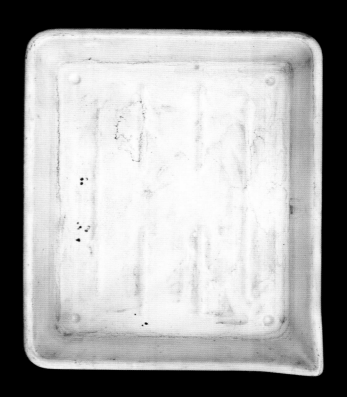

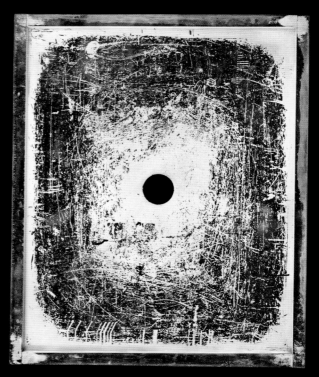

Aaron Siskind
Joni Sternbach

119

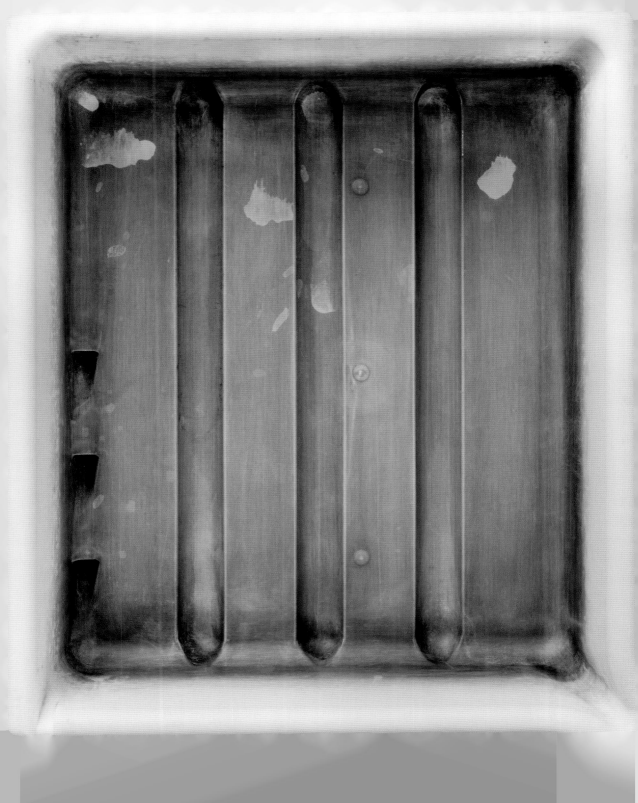

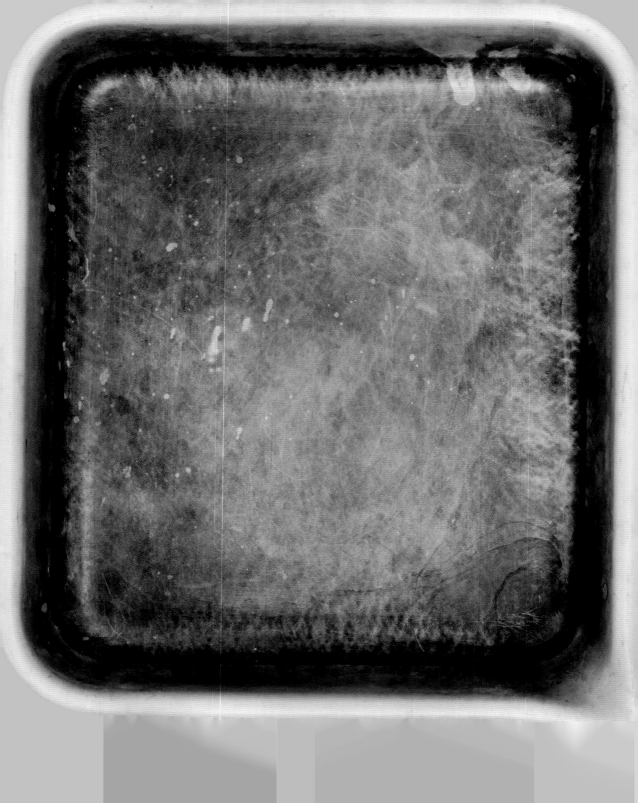

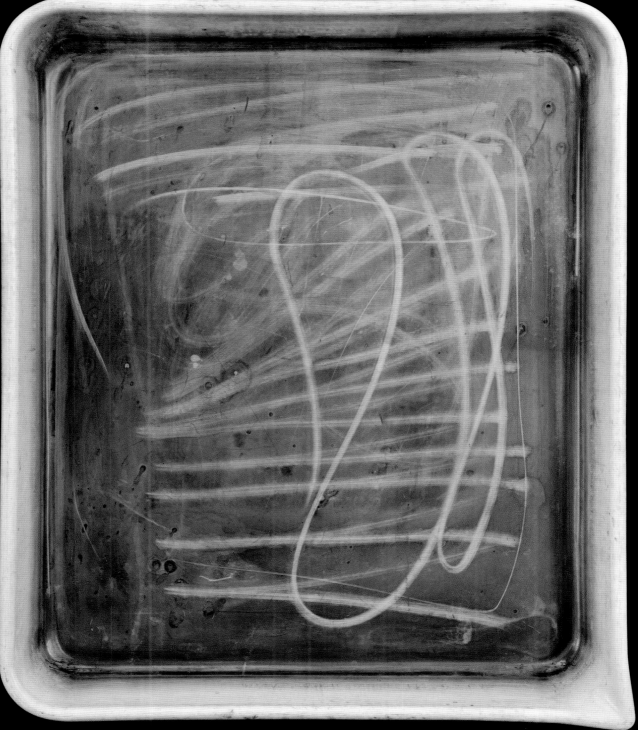

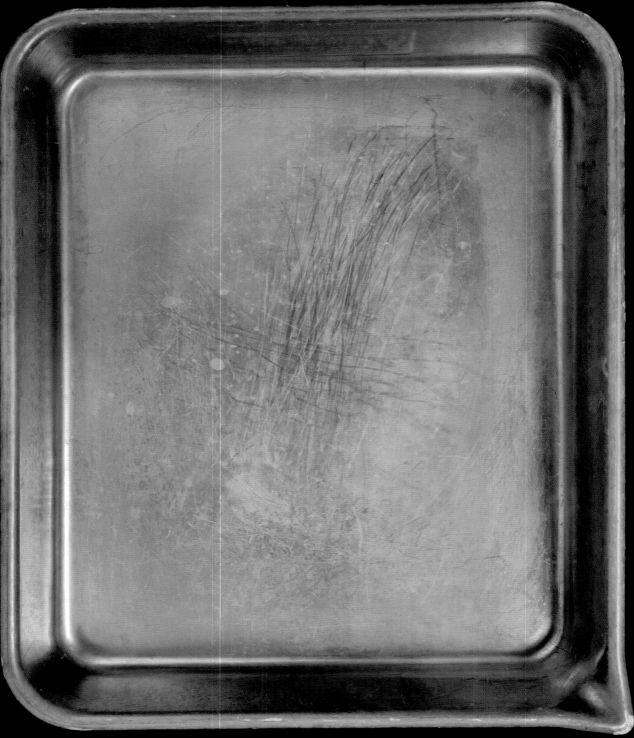

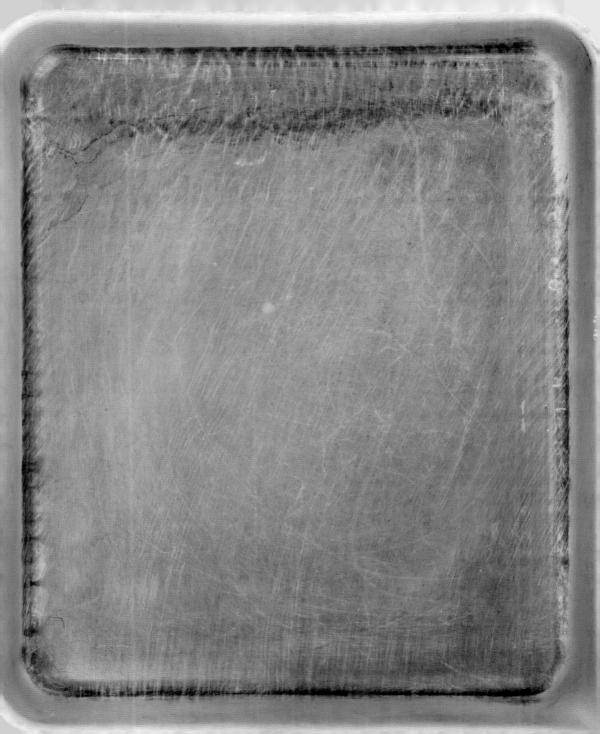

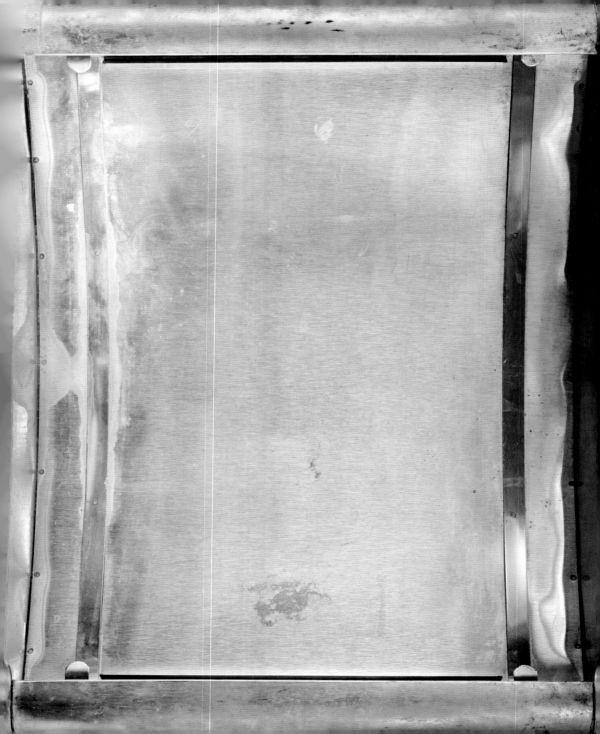

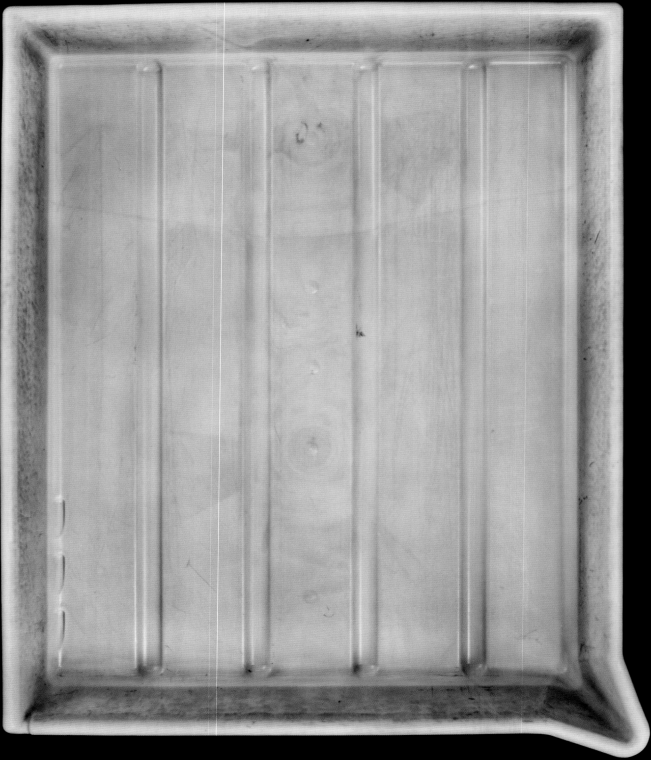

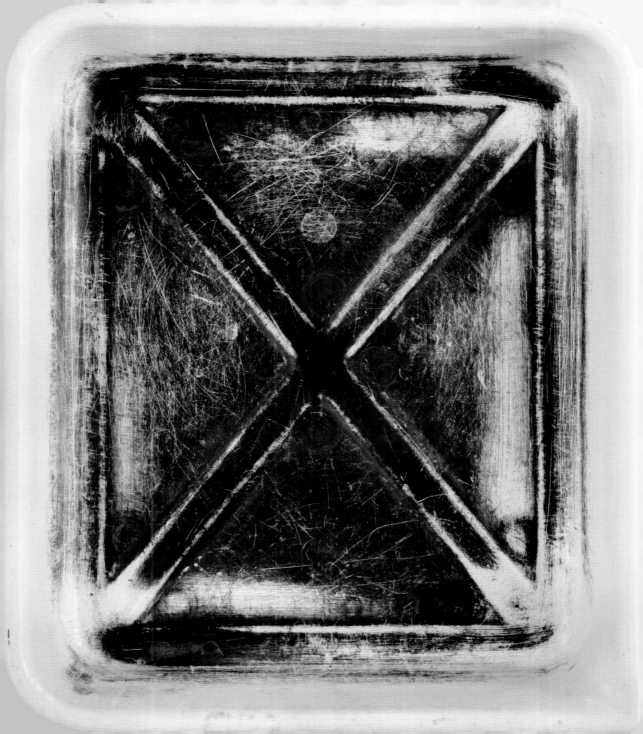

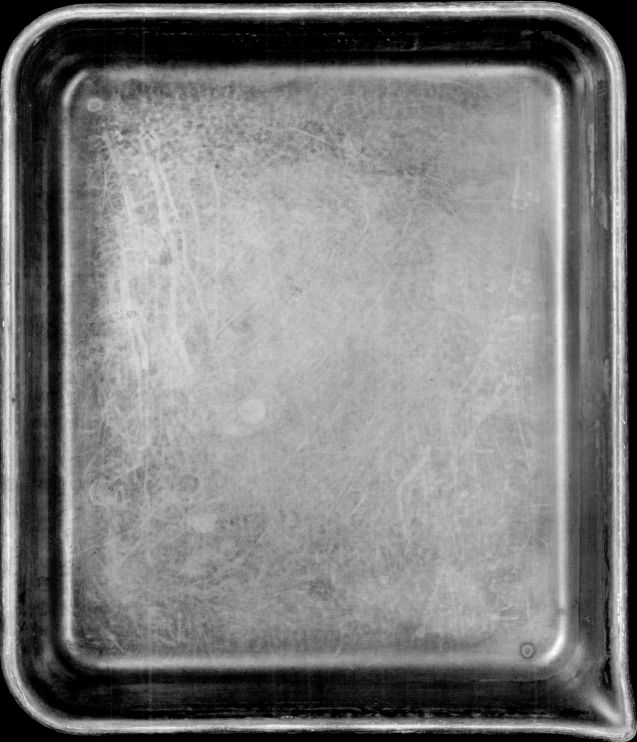

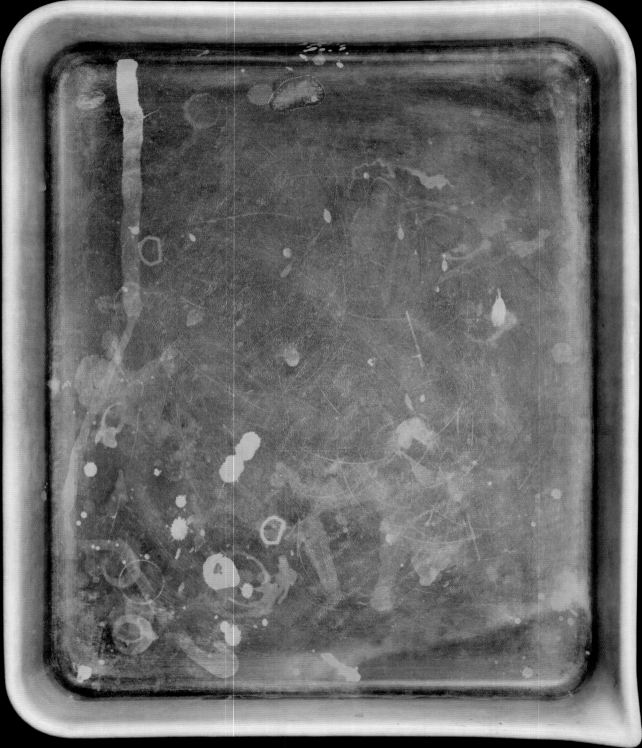

INDEX/NOTES ON TRAYS

Sizes listed correspond to the developer tray depicted

INDEX / NOTES ON TRAYS

ACKNOWLEDGEMENTS

This project could not have come to be without the generous support and involvement of my family, friends, and colleagues. I am fortunate and grateful to have you all in my life.

Thanks to my wife, Rebecca, for your enthusiastic help in all aspects of this project. I am reminded every day what a privilege it is to share my life with you. To my parents, Carol and Maury, your support has truly made me feel that anything is possible. You have taught me to choose my own path and to always follow my heart. And to my aunts, Elaine and Chris, your excitement and interest in my early creative endeavors helped guide me to pursue a life in the arts.

I would like to thank Catherine Edelman for your early and continued belief in my work. Your guidance and advice has taken my work places that I never imagined it could go. Thanks to Craig Cohen, and the entire team at powerHouse Books, for your interest in bringing my work to a wider audience through publishing. And thanks to Lyle Rexer for your insightful essay on my work.

I would also like to thank Jim Megargee for teaching me how to print and guiding me through my first years working in New York City. You taught me the subtle differences between a great print and an exceptional print and to never settle on a print that isn't the best it can be.

Thank you to all the photographers, friends, curators, and historians that have helped me in all stages of this project's development: Michael and Jeanne Adams, Alyssa Adams, Janine Altongy, Anthony Bannon, Tom Baril, Fred and Laura Bidwell, Lorne Blythe, Barbara and Gene Bullock-Wilson, Bill Burke, Tim Campos, Ellen Carey, Mark Cohen, Lois Conner, Linda Connor, Kathy Connor, Valdir Cruz, Bruce Davidson, Karen Davis, Beatriz Diaz, Elliott Erwitt, Dan Estabrook, Susan Evans, Luis Fabini, Larry Fink, Denis Finnin, John Fitzgerald, Abe Frajndlich, Brigitte Freed, Adam Fuss, Ralph Gibson, Barbara Gilbert, Julie Graham, Eugene Gologursky, John Goodman, Emmet Gowin, David Graham, Ed Grazda, Stanley Greenberg, Marvin Heiferman, Ted Hendrickson, Lizzie Himmel, Henry Horenstein, Dutch Huff, Judy Jacobs, Ann Jastrab, Jessica Johnston, Sid Kaplan, Chuck Kelton, Builder Levy, Juli Lowe, Vera Lutter, Alen MacWeeney, Sally Mann, Edward Mapplethorpe, Chris McCaw, Jim Megargee, Amanda Means, Julie Melton, Barbara Mensch, John Messenger, Richard Misrach, Andrea Modica, Andrew Moore, Abelardo Morell, Eric Newman, Olivia Parker, Shannon Perich, Kenneth Pietrobono, Sylvia Plachy, Eugene Richards, Stuart Rome, Alison Rossiter, Ken Rosenthal, Andrea Santolya, David Saul, Gary Schneider, Mark Seliger, Neil Selkirk, John Sexton, Mark Sink, Joni Sternbach, Helen M. Stummer, George Tice, Charles Traub, Eileen Travell, Jerry Uelsmann, Catherine Wagner, Harvey Wang, Hiroshi Watanabe, Kim and Gina Weston, Joel-Peter Witkin, and Bonnie Yochelson.

DEVELOPER TRAYS

© 2014 John Cyr
Introduction © 2014 Lyle Rexer

Published in the United States by powerHouse Books,
a division of powerHouse Cultural Entertainment, Inc.
37 Main Street, Brooklyn, NY 11201-1021
telephone 212.604.9074, fax 212.366.5247
e-mail: info@powerHouseBooks.com
website: www.powerHouseBooks.com

First edition, 2014

Library of Congress Control Number: 2013953967

Hardcover ISBN 978-1-57687-687-9

Printing and binding by Midas Printing, Inc., China

Book design by Krzysztof Poluchowicz

10 9 8 7 6 5 4 3 2 1

Printed and bound in China